**Rules of the
McDonald Free Library**

This book may be kept
fourteen days.

A fine of five cents a day
(including Sundays and holi-
days) must be paid on all
books kept overtime.

Borrowers must pay for
books lost or damaged while
charged on their cards.

DEMCO

WOMAN'S DAY

Y'ALL

by Dennis Droge

BOOK OF

IGRAPHY

and Janice Glander-Bandyk

SIMON AND SCHUSTER | NEW YORK

Copyright © 1980 by CBS Publications, The Consumer Publishing Division of CBS, Inc.
All rights reserved
including the right of reproduction
in whole or in part in any form
Published by Simon and Schuster
A Division of Gulf & Western Corporation
Simon & Schuster Building
Rockefeller Center
1230 Avenue of the Americas
New York, New York 10020
SIMON AND SCHUSTER and colophon
are trademarks of Simon & Schuster
Illustrations by Janice Glander-Bandyk and Hallie Coletta
Calligraphy by Dennis Droge and Janice Glander-Bandyk
Photographs by Harold Zipkowitz
Designed by Edith Fowler
Manufactured in the United States of America

1 2 3 4 5 6 7 8 9 10

Library of Congress Cataloging in Publication Data

Droge, Dennis.
 Woman's day book of calligraphy.

 1. Calligraphy. 2. Handicraft. I. Glander-Bandyk,
Janice, joint author. II. Woman's day. III. Title.
Z43.D75 745.6'197 79-27561

ISBN 0-671-25018-3

Acknowledgment

To those people whose paths have crossed ours,
and who in whatever guise they were first met
have turned out to be mentors,

WE
THANK
YOU

Dedicated to my nonalphabetic progeny, Ingrid Bandyk.
If all my letters were
as graceful and as open in spirit as she,
I would be content.

Janice Glander-Bandyk

Contents

INTRODUCTION

Building calligraphic skills is like building a house: you lay the foundation first and work your way to the finishing touches. This book is designed to teach you five basic calligraphic styles (or "hands") of lettering the alphabet, and give you simple instructions to make a variety of projects. Once you've mastered the basic skills, you will see how satisfying and *easy* it is to make a family tree or even your own wedding invitations!

Have fun with the book. We hope the 15 projects here inspire you to make many more with your ingenuity and new found talent. What you'll need is a little discipline and determination. The creativity takes care of itself.

Dennis Droge

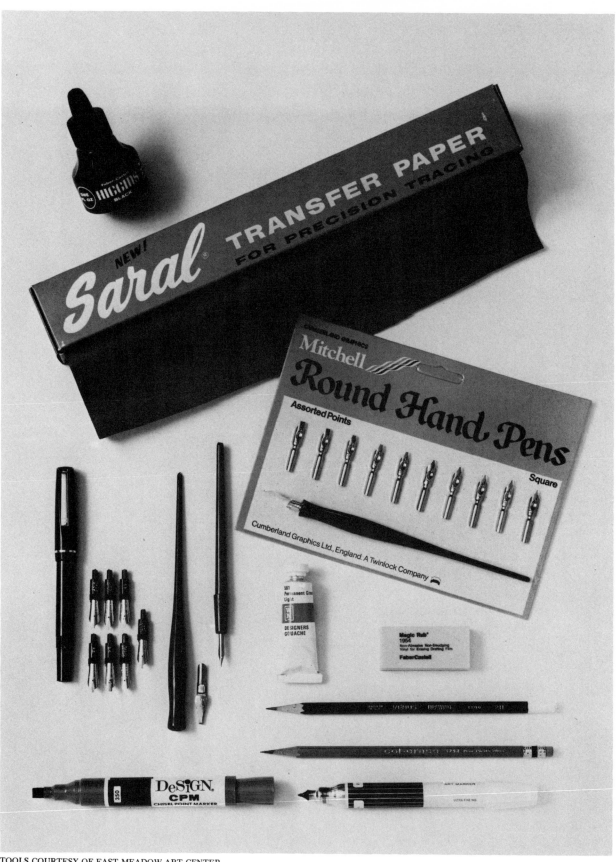

TOOLS COURTESY OF EAST MEADOW ART CENTER

chapter

1

BEGINNING

Tools

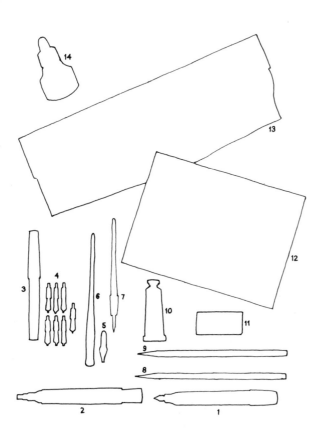

You won't need much money or equipment to begin your enjoyment of calligraphy. We've listed here the few simple tools that you'll need to practice the letters and make the projects.

(1 & 2) We used a *felt-tip marker*, available in (1) *fine point* and (2) *chisel point* (broad edge), to make a few of the borders on the projects. It's an easy pen to work with, and you might want to initially practice your lettering with it.

(3) A *chisel edged fountain pen* is the calligrapher's essential tool; it enables you to make letters of many sizes and thicknesses. You should practice the lettering and make the projects in the book with it. Buy a *lettering* fountain pen set, not an *italic*, because it has a wider variety of nibs and makes a much larger variety of letter sizes.

(4) The fountain-pen point, or *nib* (you'll hear it referred to as a broad-edge, square or chisel nib), is screwed into the end of the

pen barrel. Pen barrels and nibs are sold separately or in sets.

(5) A *left oblique nib*, a special nib for lefties, with a slant to the left, is for those who write with a hooked hand and tend to smear the ink of the letters they've just made. Two brands, *Osmiroid* and *Platignum*, make lettering sets that include five or six interchangeable nibs (sizes ranging from *fine to medium, broad, B-2, B-3* and the largest, *B-4*).

(6) *Speedball* makes dip pens (you simply dip the pen into a bottle of ink) with interchangeable nibs.

(7) A *crowquill dip pen* produces very fine lines. One size.

(8) A *nonreproducing pen* or *pencil* is a special one that you use if you are going to have a printer make copies of something. The pencil marks will be invisible to the printer's camera, so you can mark up the original drawing without having it show on the copies.

(9) A *2H pencil*, found in art stores, is a slightly hard pencil that will keep its point well.

(10) *Winsor and Newton Designers Colors Gouache* (pronounced "g'wash") is a water-base paint. Use it in lieu of ink with a dip pen, for color.

(11) A *plastic magic eraser* won't smear the ink or make crumbs.

(12) The *Mitchell "Round Hand" Pen Set*, a sophisticated dip pen, offers an assortment of 10 nibs that enables the calligrapher to produce exquisite thin lines.

(13) *Graphite paper* is a special paper coated on one side with graphite. Use it to transfer a design from one piece to another.

(14) Use *Higgins India ink* for your dip pens, and when you need a solid black ink (for example, when you want a printer to make copies of a design you've made). NEVER use India ink with a fountain pen; the ink will clog the pen's fixtures. *Osmiroid*

Fountain Pen Ink (not shown) is a good all-purpose ink, suited for your fountain pen.

Letters Taking Shape

We are surrounded by letters. Television, newspapers, magazines and signs everywhere bombard us with these symbols, all members of the alphabet, which record our language.

Thumb through any magazine and look at some of the *majuscules* (pronounced mah jes'kewlz), which are the capital letters. Regardless of whether they are printed or written, you can generalize about their design. For an example look at the A.

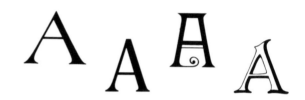

Some A's are short and fat. Others look tall and skinny, with rounded ends, or pointed ones. Some have thick and thin parts. Some have feet, also called *serifs*. Despite their distinctions, they all share a basic linear form; the majuscule A is always made from two diagonal lines and one horizontal line.

Some letters are composed of all straight lines.

Some are made from diagonals.

Some have curved strokes.

C GOQS

Many are a combination of different strokes.

ABDJKM
NPRUYZ

Thick and Thin Strokes

No matter what the shape, every letter is made up of calligraphic strokes. Each stroke has two parts (actually, two strokes): a thick and a thin. You make the *thick* one by pulling the full edge of the nib down on the graph paper.

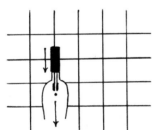

You make the *thin* stroke, or *hairline*, by pulling the nib to the right on its razorlike edge (keeping the full edge of the nib on the paper, the same as before).

Note: the thin stroke, or hairline, is *always* made at a 90-degree angle, or right angle, to the thick stroke.

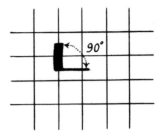

Pen Angle

The most important thing for you to understand is the pen angle. It is not the angle of the pen (or your arm) to the paper, but the angle of the stroke to the lines on the graph paper. Let's discuss a *30-degree pen angle*.

Draw a circle. Draw a horizontal line bisecting the circle. This is your *writing line*.

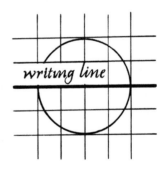

Draw a vertical line perpendicular to the writing line. This is your *vertical*.

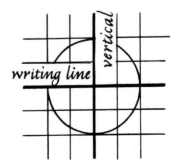

Draw a thick stroke from the edge of the circle *at a point that is 30 degrees to the left of the vertical* down to the center of the writing line.

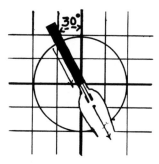

Without moving the nib from the paper, make a hairline that is 90 degrees to the right of the thick stroke, or 30 *degrees above the writing line*.

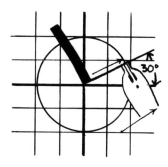

Thus, a stroke with a 30-degree angle is one in which the thick stroke is made at an angle 30 degrees to the left of the vertical and the hairline is made at an angle 30 degrees to the left of (or above) the writing line.

Different hands employ different pen angles for their strokes. The Roman Majuscule, the first hand you'll use, works with a 30-degree pen angle and a 45-degree pen angle. You should note now, to avoid confusion later, that the thickness of the stroke varies with the pen held at different angles.

If You're Left-handed

Many lefties assume that they are destined to a life without calligraphy. What with a background so sinister (Latin for "left") and gauche (French for "left"), and dancing with two left feet, it is no wonder that left-handed people think they cannot be calligraphers. The fact that our writing system dictates that we write from left to right puts lefties at a disadvantage from the start. But take heart: not only is calligraphy possible for left-handed people, some of the best calligraphers are sinistral.

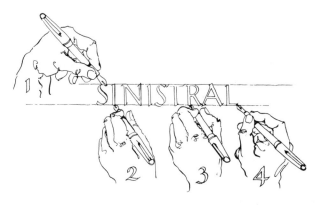

A few suggestions for left-handed calligraphers, from left to right:

1. The "hooked hand" is very awkward because the hand is always traveling across wet ink. People with this grasp sometimes try special pens that have left-oblique (rather than square) nibs for left-handed people.

2. This grip, with the thumb parallel to the pen, is good for lefties.

3. If you cannot straighten your thumb, try turning the paper to the left, which will pull your left arm away from your body and allow it more freedom of movement.

4. You can always switch to your right hand.

chapter

2

ROMAN
MAJUSCULE

THE ROMAN
MAJUSCULE
WAS PERFECTED
ABOUT A.D. 100

Pen Angle

Roman majuscule, the most fundamental of calligraphic styles, is written at a 30-degree angle.

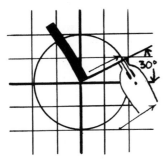

To clarify this concept further, think of a clock on your paper. To make the fattest stroke possible, pull the nib from 11 o'clock to the center of the circle (note that the angle between 11 and 12 is 30 degrees). Without moving the angle of your pen, sweep the nib up to 2 o'clock on a hairline, making the thinnest stroke possible (and note the 30-degree angle between 2 and 3).

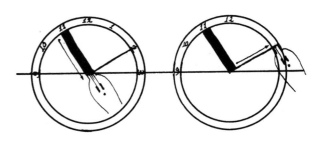

Letter Height

The height of your letter looks best when it's in direct proportion to the size nib that you use. Roman majuscules look best at the height of your nib stacked 7½ or 8 times.

Basic Strokes

Most Roman majuscule strokes begin with a hairline. Slide the pen to the right on a hairline at a 30-degree angle and, without lifting the pen from the paper, make a thick stroke down to the writing line. At the bottom of the stroke, make another hairline up and away to the right. These short hairlines at the beginning and end of strokes are *serifs*. Try to make a few of these vertical strokes.

Begin and end the diagonal strokes in the same manner.

Horizontal strokes too . . .

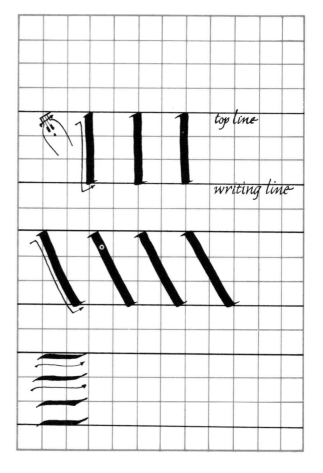

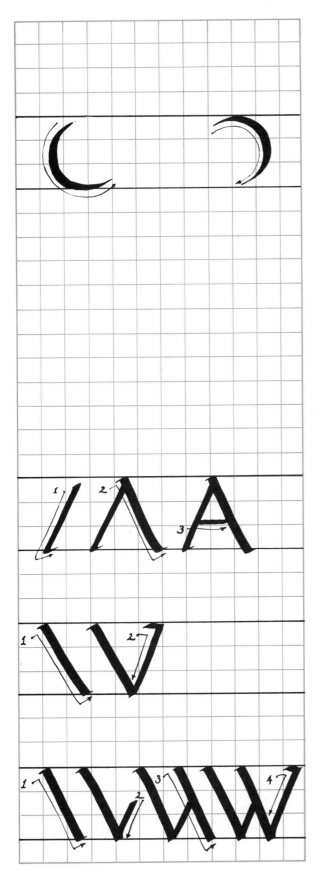

For the curved strokes, imagine the clock again. Beginning at 11 o'clock, follow the circle edge of the clock down and around to 5 o'clock. If you maintain the 30-degree angle to the writing line, the stroke will begin as a hairline, gradually thicken and then narrow down to a hairline. Follow the other half of the circle, beginning the hairline at eleven, continuing the stroke to the right and ending at five once again.

Posture is fairly important. Be sure to sit erect and hold the pen lightly, almost vertical to the paper. The graph paper should be square in front of you and not slanted to the right or left. It is much easier to draw a straight line vertically or horizontally if the paper is square in front of your eyes.

The A is made with the pen held at a constant 30 degrees to the writing line. In this case do not begin the first stroke, the left leg of the letter, with a hairline. Instead, begin just below the top line; the second diagonal stroke will fill the gap at the top. The cross stroke looks best if drawn slightly below center.

The V is also made with two diagonal strokes. The balance of the letter depends upon the width of the top opening (almost three boxes on ¼-inch graph paper).

The W is a continuation of the V.

The first stroke of the M and the first and last strokes of the N are made with the pen held at a constant 45-degree angle to the writing line. Returning to the clock, tilt your pen angle from 11 o'clock to 10:30. The hairline should arrive at 1:30.

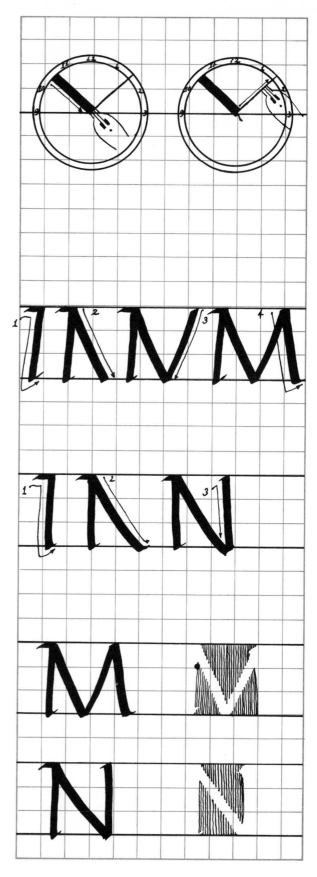

The first stroke of the M is made at a 45-degree angle, and the other three strokes are made at a 30-degree angle. The width of the top opening is similar to that of the V—about three boxes on the graph paper.

The first stroke of the N is made at a 45-degree angle, the second is made at a 30-degree angle, and the third returns to the 45-degree angle.

The appearance of your letters depends upon not only the black strokes but the white space between the strokes as well. This counterspace, or negative space, helps you determine whether or not you are making letters of sound design.

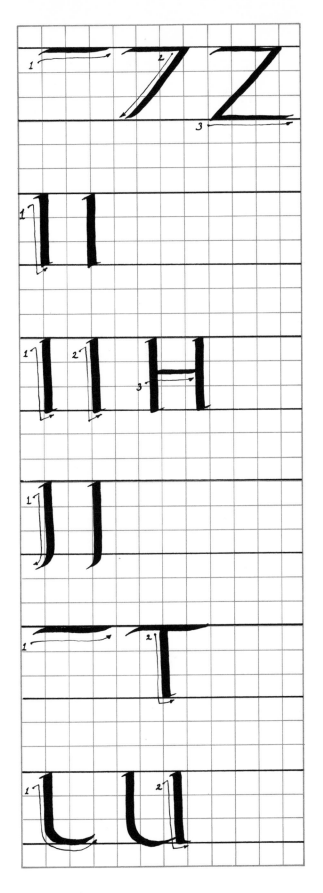

Z is another stroke with two pen angles. The first and last strokes are made at a 30-degree angle to the writing line. For the middle stroke, however, you should shift the pen angle to zero degrees (12 o'clock).

The I is a one-stroke affair. You have made several like it already by practicing the basic vertical stroke.

H is made with two basic vertical strokes that are connected slightly above center with a horizontal stroke.

The J begins as a vertical, and you finish it by pulling the stroke to the left just below the writing line.

The T is a long horizontal at the top line and a vertical to hold it up.

Be sure to keep the first stroke of the U straight, coming down almost to the writing line before making the stroke curve to the right.

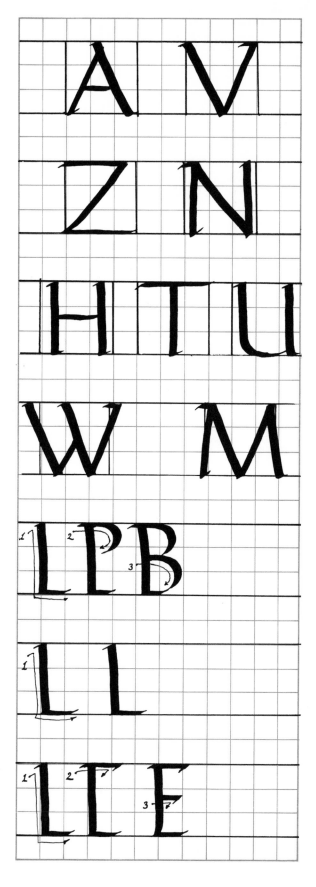

With the exception of M and W, which are wider, the widths of the letters so far are equal.

Next are the narrow letters, whose widths are one-half to two-thirds the size of their lengths. Notice that the first stroke in the B, L, and E is the same, and that the first stroke

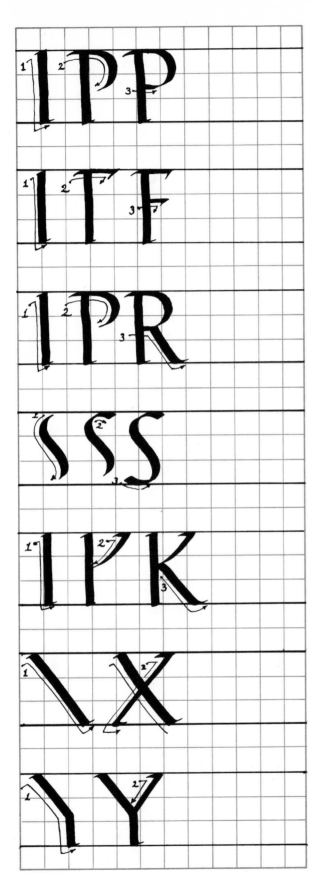

in the P, F, and R is the same. All letters are composed of similar strokes, and each writing style has a modular quality.

Take your time with the S and avoid making it twist and curve too much. The first stroke begins curved below the top line, straightens out, and finishes curved above the bottom line. The second and third strokes are made from left to right.

The strokes of the K and X meet slightly above center. The Y looks best when it comes together slightly below center.

The rest of the letters are made with round strokes that begin and end on a hairline. To avoid having these letters look shorter than the rest of the alphabet, drop the curved strokes slightly below the writing line.

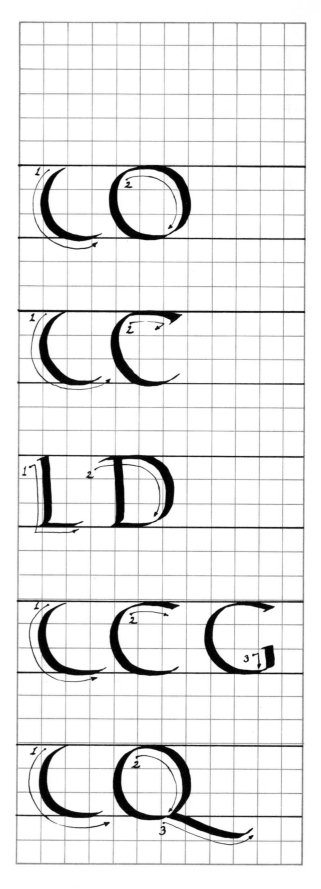

The O is extremely rounded; the outer perimeter should be as near to a perfect circle as you can make.

The first stroke of the C is the same as the beginning of the O, and the second stroke is somewhat flat before it comes to a halt with a serif.

The D begins with the same stroke as the L. The second stroke remains flat on top before billowing out and down, then back to the left to meet the hairline of the second stroke.

The G has the two strokes of the C and a third short vertical stroke that begins just below center and comes down to the tip of the first stroke.

The Q is an O with a tail.

Think of punctuation marks as visual clues and keep them small and unobtrusive.

Spacing

Spacing enhances the texture and legibility of the written word. It is probably the least obvious and most important aspect of fine lettering. Helpful to calligraphers in determining the space between letters has been a particular water image. Think of pouring water into the spaces. Each space, whatever its shape, must contain an equal amount of water. As for spacing between words, leave enough space between words in which to fit an O.

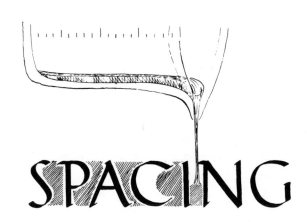

ROMAN PROJECTS

Roman Roundup

You might be called upon by a local civic group to display your calligraphic talent, or you just might want to give a present of your favorite saying. If the phrase is short and sweet, you might want to use an easy design like the one on page 26.

SUPPLIES

1. Dark blue poster board or thin cardboard, called railroad board.
2. Colored felt squares.
3. Speedball pen nib (size C-2) and holder.
4. Plastic palette with wells.
5. Scissors.
6. 2H pencil.
7. Gouache (pronounced g'wash), a water-

based paint, such as Winsor and Newton Designers colors (white).

8. Plastic magic eraser.
9. Small brush for mixing paint.
10. Water container.
11. Elmer's Glue.
12. A round dish or casserole cover to trace.

PROCEDURE

A. Place the dish in the center of the board and trace lightly around it.

B. If you have more characters (each letter, punctuation mark and space counts as one character) than I used in the example, draw your next line outside the first circle. If you have about the same number, draw the concentric circle inside the first circle. Your letter should be about ⅝″ high, which means that your second line should be ⅝″ from the first. (If you are using a different pen nib, first make a pen scale to determine the distance of the second line from the first.)

C. Pencil in your letters lightly to find the approximate amount of space they will take. Don't bother to erase unless you are moving them around.

D. Squeeze a little paint (the gouache) onto a plastic palette and mix with water until it has a consistency of light cream.

E. Paint the nib with a brush (never dip a nib into paint) and letter. Be sure first to test the amount of paint on the pen on a piece of scrap so that you don't blob. If the paint seems to bead on the board, add a drop of liquid dishwashing detergent to the mixture.

F. Let the letters dry. When they're thoroughly dry, erase gently.

G. Cut out the felt squares in whatever shape you like. You can trace glasses, cookie cutters—anything you like.

H. Put Elmer's Glue on the back of the shapes after you have determined where to place them on the layout. Paste them down.

I. You might want to put a piece of waxed paper on top of them and weight them with a book and then let them dry.

J. Frame.

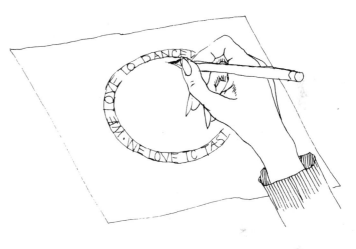

Bookplates

Wouldn't it be nice to personalize your books with a bookplate! Bookplates remind people that the books they've borrowed belong to you, and make a great present for your favorite bookworm or family philosopher.

You might want to duplicate your design. There are several ways: You can make each bookplate by hand, which is quite a laborious process. You can prepare the design, take it to a local printer or stationer, and, for very little money, have bookplates printed. Or you might ask the printer to make a rubber stamp, which is also inexpensive.

SUPPLIES

1. A 2H pencil and a plastic magic eraser, if you are making each bookplate individually.
2. A nonreproducing pencil, which is a spe-

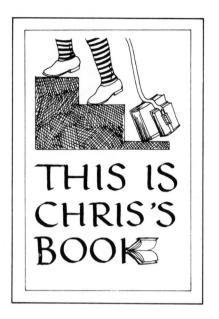

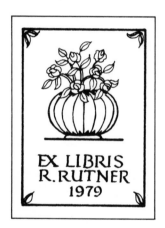

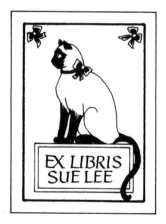

cial pencil that will be invisible to the printer's camera (so you don't have to erase), if you are going to take the design to a printer and have copies made.

3. Paper for the bookplates.

4. You can either draw a picture or trace one from a magazine or book.

5. A ruler and a T-square.

6. Fountain pen lettering set.

7. Fountain-pen ink, if you are making each bookplate individually.

8. India ink, if you are taking the design to the printer.

PROCEDURE

A. Determine the size of the bookplate.

B. Decide how you want to reproduce the bookplates. If you plan to make each one by hand, sketch with a 2H pencil, work with fountain-pen ink, and erase the pencil marks carefully. If you plan to take the design to the printer, practice with a nonreproducing blue pencil. (If you want to have a rubber stamp made, prepare the design as you would for a printer.)

C. Practice the design and lettering of the bookplate on scrap paper. When you are satisfied, transfer the guidelines in pencil to the paper you've chosen for the bookplates.

D. Draw and letter with ink. Let dry.

E. If you take the board to the printer, perhaps you would like to have the labels printed with gummed backs.

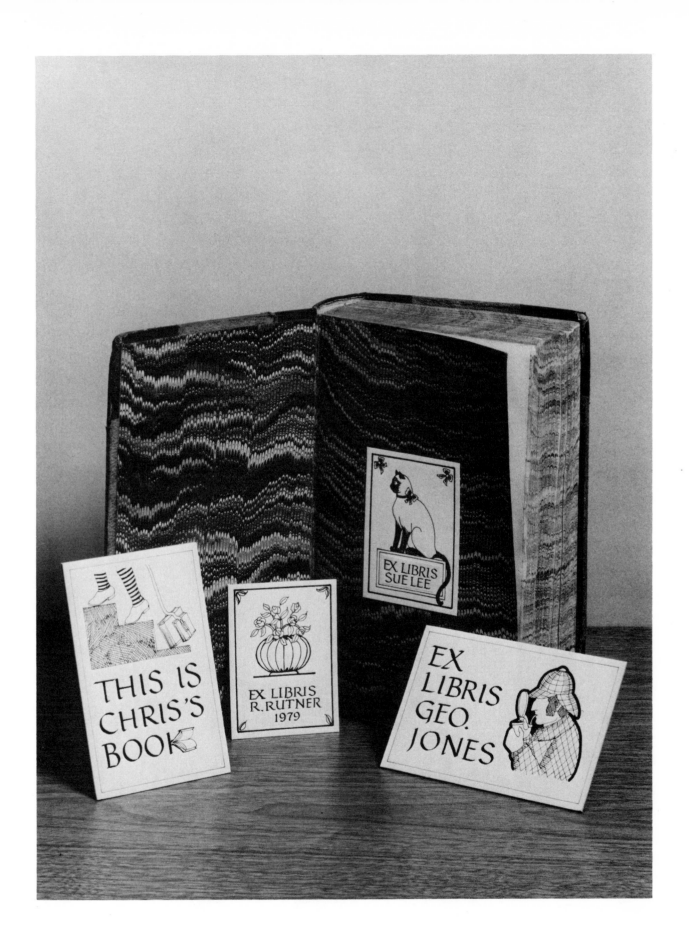

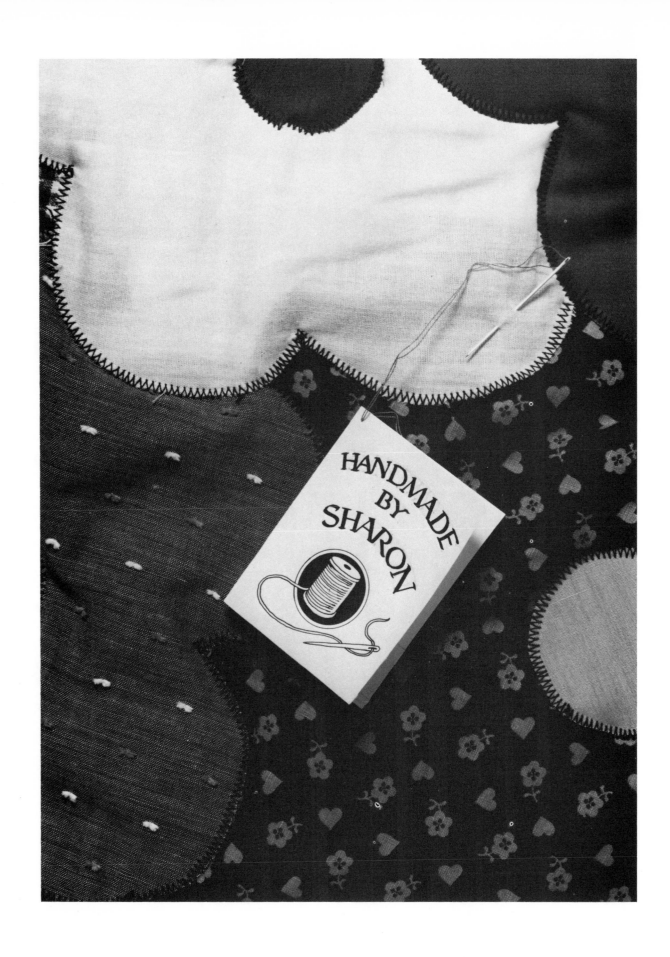

Crafts Tag

This project is comparable to serving the perfect dessert; it's the ideal finishing touch you can add to wonderful handmade sweaters, quilts, potpourris, sachets, and so on. You can trace our spool design or make one that is simple and elegant. It will enhance the beauty of the gift as well as identify it.

SUPPLIES

1. Bond paper for the tag.
2. A quarter.
3. 2H pencil.
4. Fine felt-tip marker.
5. Fountain-pen lettering set.
6. Fountain-pen ink.
7. A teacup.
8. Plastic magic eraser.

PROCEDURE

A. Make a card from a 4″ × 2⅝″ piece of bond paper (when folded, the card will measure 2″ × 2⅝″).
B. Draw or copy the picture of the spool lightly onto the tag.
C. Put a quarter over the picture of the spool and trace around it lightly.
D. Use a teacup as an edge to pencil in three arcs that will serve as your writing lines.
E. Letter on the tag after you have practiced elsewhere.
F. Draw or trace the loose thread and the needle and fill in the black background with the felt-tip pen.
G. Erase pencil lines with the plastic magic eraser.
H. Fold tag and attach to gift with needle and thread or a ribbon.

chapter **3**

UNCIAL

ᴄhe ɴαɱє uɴᴄιαʟ (uɴ'ѕhι-αʟ) ᴅαᴄєѕ

вαᴄκ ᴄo ʀoɱαɴ ᴄιɱєѕ, ɯhєɴ ʟєᴄᴄєʀѕ

ɯєʀє ѕuppoѕєᴅʟy ɯʀιᴄᴄєɴ αᴄ α

hєιɢhᴄ oᴩ oɴє ʀoɱαɴ ιɴᴄh, oʀ "uɴᴄια"

As scribes were called upon to write more and more frequently, their need increased for quickly written, legible letters. They began to cut corners with Roman majuscules, which were extremely slow letters to execute. The scribes used fewer strokes to make letters and put curves into lines that were previously straight. This new style, called uncial, had much more of an organic appearance than the geometric shapes of the Roman majuscule style.

Pen Angle

Imagine the clock on your paper again. Holding your pen at 11:30 (rather than at 11, as you would for the Roman majuscule), pull the stroke down to the center of the clock at

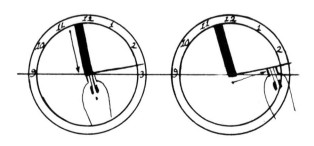

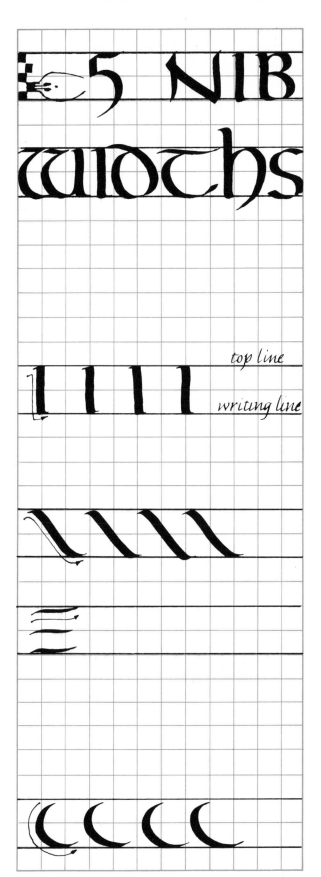

this 15-degree angle. Keeping the pen on the paper at the same angle, draw the pen to the right to make a hairline up to 2:30.

Letter Height

Uncial letters, shorter than Roman majuscules, are made at a height of five stacked nib widths.

Basic Strokes

As with Roman majuscules, the strokes of uncial letters begin and end on the hairline. Slide your nib to the right on the top line to make a serif, pull the stroke down to the writing line, and finish the stroke by making another short serif to the right.

Starting again at the top line with a serif, pull the pen down and to the right in a diagonal stroke, making sure you maintain the 15-degree angle. Notice that the diagonal stroke will be thinner than the vertical stroke.

Horizontal strokes are made like the Roman majuscules, except that the nib is held at 15 degrees to the writing line.

The curved uncial strokes seem broad and flat when compared to the circular strokes of the Roman majuscule style. Beginning slightly below the top line, pull the pen to the left and down and then to the right. Notice that the stroke is extremely curved at the beginning and flattens considerably toward the end.

To make an opposing curved stroke, begin at the top hairline of the first curved stroke you have made, proceed up and to the right to touch the top line and then down and around to the left to meet the hairline of the first stroke. This time, however, begin the flat shape on the top and tighten the curve gradually as you near the bottom. These two opposing strokes together create an uncial O that is completely balanced in its design.

Make the first stroke of the A at the top line by sliding from the serif into the diagonal, down to the right, and onto the writing line with a hairline. Remember to keep the diagonal straight; these strokes can twist and curve with speed. Begin the second stroke as a hairline and cause it to thicken gradually as it falls down into the diagonal first stroke. Pull a third stroke down and to the left of the connecting stroke, stopping at the writing line. Without lifting your pen, slide the nib to the right to meet the first stroke with a hairline.

Begin the B with a basic vertical stroke. A short connecting stroke much like the one you made in the A falls from the right into the vertical stroke. Now complete the first bowl as shown, reconnecting with the vertical stroke, or stem, just above center. Complete the second bowl, ending at the vertical's bottom serif.

Begin the C with a basic curved stroke slightly below the top line, making the curve tighter at the top than at the bottom. Remember to begin and end the stroke on the hairline and to maintain your 15-degree angle. Begin the second stroke at the top hairline of the first; then move it to the right and up to touch the top line before descending slightly. Stop shortly thereafter.

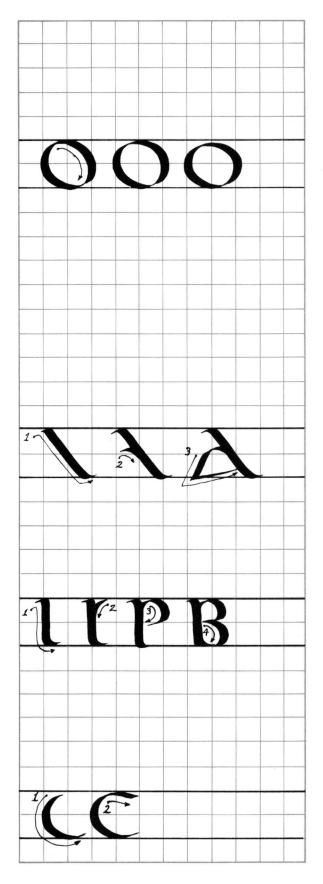

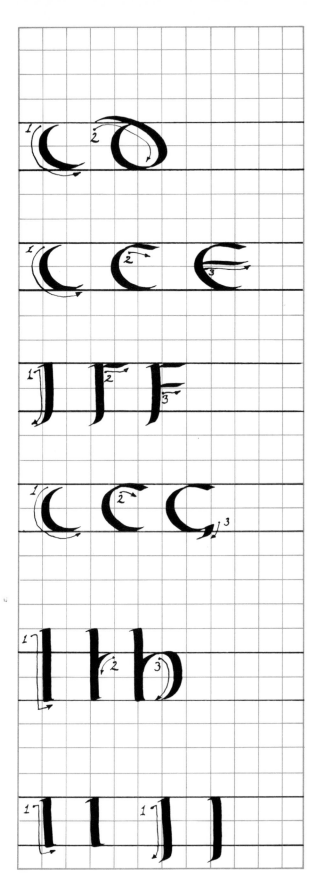

The first stroke of the D is the same as that of the C. The second stroke is the same as an opposing curved stroke except that it begins above the top line. Any stroke that extends above the top line is called an *ascender*. This stroke is flat at the top and curves gradually before meeting the first stroke near the writing line.

The first two E strokes form a C. The third is a horizontal stroke slightly above center. If this stroke winds up as a hairline, that means you are at zero degrees, or 12 o'clock, and should correct your angle to 15 degrees.

The first stroke of the F begins with a serif, travels down, and breaks slightly below and to the left of the writing line. Complete the letter with two horizontals: one at the top line and one slightly below center.

The G is made like the C and has a short vertical tail that ends with a slide to the left on the hairline.

The H begins with a vertical ascender stroke. A short connecting stroke is next, beginning to the right of the stem at the top line and curving down to meet the stem. Finish the H with a curved stroke as shown. Do not connect this last curved stroke to the stem at the writing line.

The I is made with one vertical stroke. The J is merely a variation of the I, the difference being that the stroke extends below the writing line and to the left on a hairline. Strokes that break through the writing line into the space below are called *descenders*.

To write a K in the Uncial style, begin with an ascender, the same stroke with which you began the H. The second stroke begins at the top line to the right of the stem and curves back to meet the stem as a hairline. The third stroke begins where the second ended and travels down and to the right on a diagonal to meet the writing line.

The L begins as an ascender, as the K did, except that upon reaching the writing line the stroke continues a short distance to the right along the writing line.

Notice that the M has changed drastically from its Roman majuscule form. It begins like a C. The second stroke begins curved and then changes to a vertical that comes down to meet the writing line. The connecting stroke that was employed in the H comes in handy here before you complete the letter with the opposing curved stroke.

The N would appear extremely thick if drawn at a 15-degree angle to the writing line. On the clock, turn the pen from 11:30 to 10:30, putting the pen angle at 45 rather than 15 degrees.

This 45-degree angle will give you narrow verticals. Notice that the diagonal second stroke overlaps the verticals of the N.

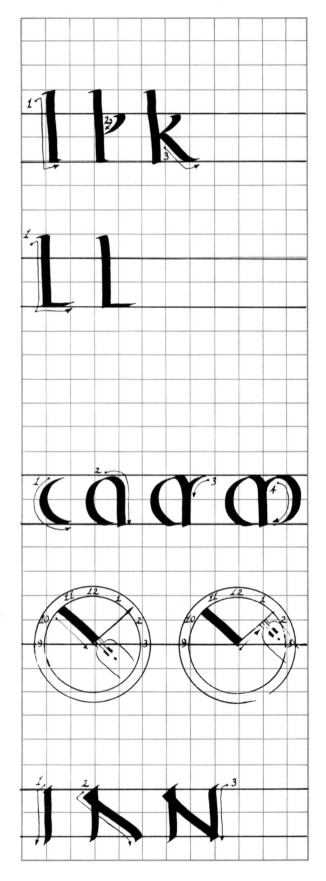

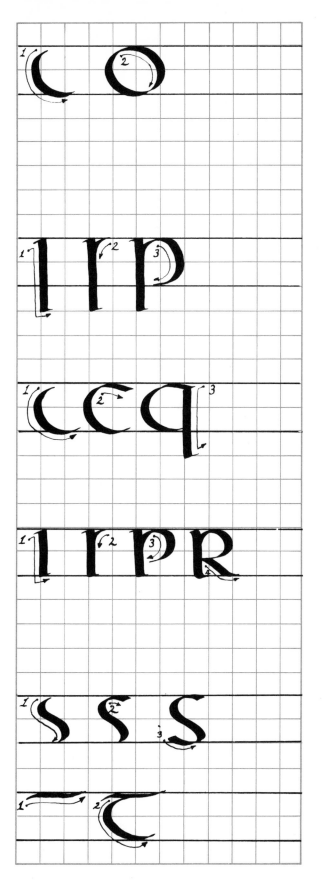

Going back to 15 degrees, you can proceed to the O. Since you have practiced these curved strokes several times by now, this letter should present no problems.

The P begins at the top line and comes straight down, breaking through the writing line and dropping below to form a descender before finishing with a hairline turn to the right. A short connecting stroke at the top of the stem is next in the manner of the H and M. The bowl is a simple opposing curved stroke.

The first two strokes of the Q form a C, and the last stroke is a vertical descender that finishes to the right on a hairline.

The R begins with a vertical stem, followed by a connecting stroke near the top line. A basic curved stroke creates the bowl, and a diagonal stroke similar to the last one of the K completes this letter.

Make the S extremely slowly, maintaining a 15-degree angle when drawing the letter. As in the Roman majuscule form, the first stroke of the uncial S begins curved, straightens in the middle, and curves to the right at the bottom. The top and bottom strokes meet the first stroke at the hairlines.

The T is simply a horizontal stroke at the top line connected left of center to a basic curved stroke.

The U starts with a short horizontal stroke at the top line which continues down into a basic curved stroke. A connecting stroke is next, and finally a vertical that begins at the top line and comes down to meet the writing line after overlapping the connecting stroke.

The V in the uncial style is pretty much the same as in the Roman majuscule style, but is written at a 15-degree angle rather than a 30-degree angle.

To make the W, repeat the first stroke of the U twice and finish it with a connecting stroke and a vertical.

The X is the same as the Roman majuscule form except that it is written at 15 degrees.

Notice that the second diagonal stroke of the Y breaks through the writing line and drops below to make a descender.

Two horizontal strokes joined by a diagonal make the Z.

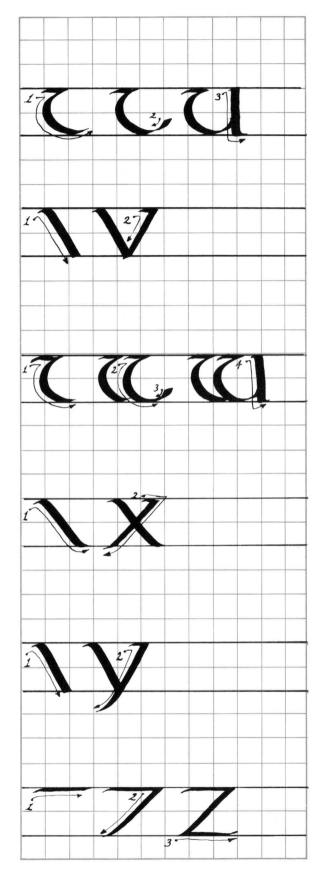

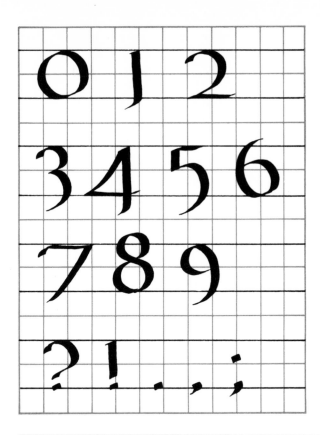

Arabic numerals should be written at a constant 15-degree angle to the writing line when used with uncials. The unique curved stroke characteristic of the uncial style should be carried over to the numerals. The same applies to punctuation.

UNCIAL PROJECTS

Kitchen Labels

After your loving labors, you should label your homemade preserves, jams, pickles, and so on. It's so simple. You can make the labels and then give the homemade goodies to friends and relatives. Or just keep your pantry pleasantly stocked.

SUPPLIES

1. 2H pencil.
2. T-square or ruler and triangle.
3. Bond pad for the labels. You might even buy blank gummed labels in the store and write on them.
4. Fine felt-tip marker.
5. Plastic magic eraser.
6. Rubber cement.
7. Fountain-pen lettering set.
8. Fountain-pen ink. (waterproof)
9. Scissors.

PROCEDURE

A. Determine a suitable label size for the jars you are using. We have used ones that are in the 2″–3″ range.
B. Lightly draw the size of the label on the pad.
C. Trace and transfer the border designs here or create your own. In either case, draw them lightly in pencil on the card.
D. Make a pen scale to determine the height of your letters. Then letter the words you're using on scrap paper to see if they'll

fit in the allotted area. Make the pen size larger if you have too much room left over, or smaller if you don't have enough room.

E. When you're satisfied, letter in ink on the bond.

F. Draw the borders with the fine felt-tip marker.

G. Erase the pencil marks.

H. Cut out the label and affix to the jar with rubber cement.

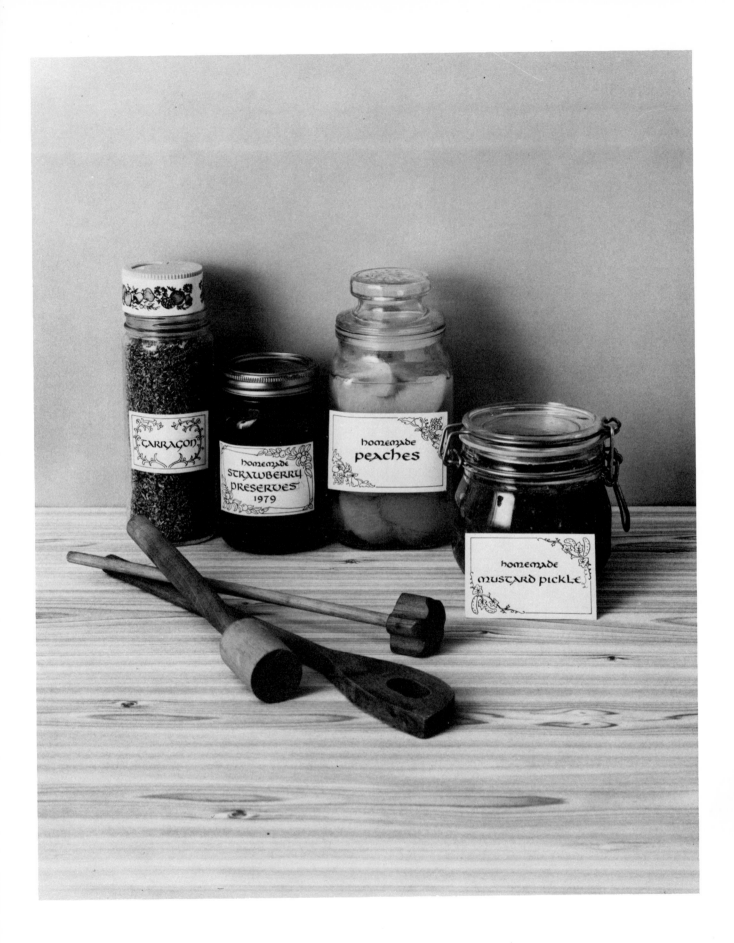

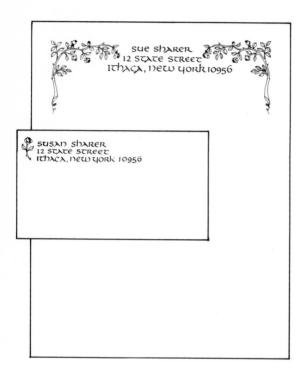

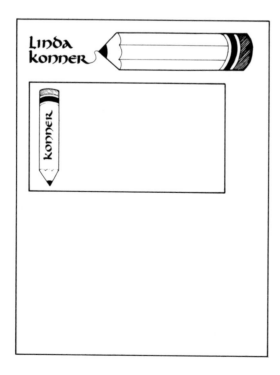

Stationery

Personalized stationery, especially if it was made and designed by you, adds an original touch to the letters you send. Choose a suitable monogram, name, or symbol for the letterhead and make the sheets individually or have a batch printed inexpensively by your local stationer or printer.

Supplies

1. Nonreproducing pencil, which is a special pencil that will be invisible to the printer's camera (so you don't have to erase), if you are going to take the design to a printer and have copies made.
2. 2H pencil, if you are making each sheet individually.
3. Letter paper.
4. Fountain-pen lettering set.
5. Fountain-pen ink, if you are making each sheet individually.
6. India ink (a very black ink), if you are preparing the design for reproduction. (After the printer has made the plate, he can print the image in any color.)
7. Rubber cement: the small jar or can with the brush in the cap.
8. Rubber-cement pickup to remove extra rubber cement.
9. Ruler.
10. Scissors.

Procedure

A. Determine the wording and art (if any) for the letterhead.
B. Sketch the wording and art on scrap paper and cut out the pieces. If you plan to make each sheet individually, sketch with a 2H pencil. If you plan to take the design to the printer, sketch with a nonreproducing pencil.
C. Arrange the pieces on paper in different ways until you find a pleasing design. Leave

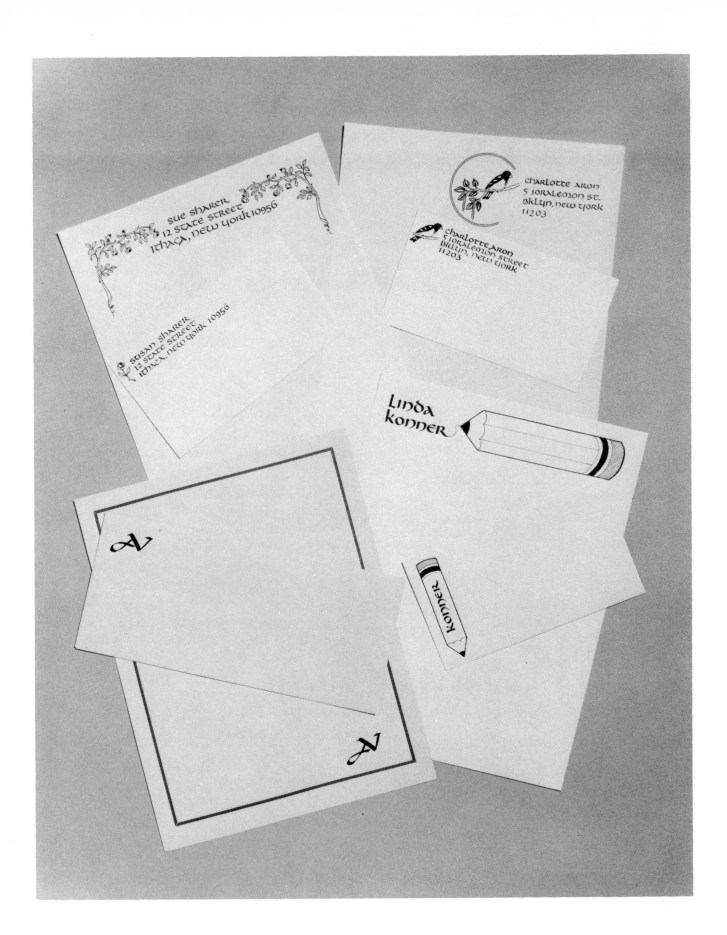

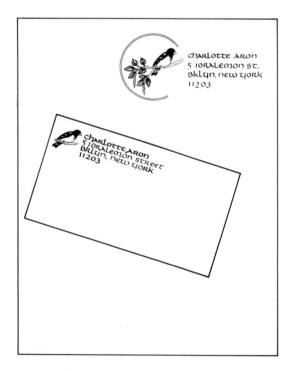

at least a ¼″ margin at the edges of the paper.

D. Paste down the pieces with rubber cement. Remove the excess rubber cement when it is dry (almost immediately).

E. To make individual sheets, simply put the design under a piece of fine stationery and trace with any fountain-pen ink. To prepare the layout for the printer, draw over the nonreproducing pencil with India ink. Let it dry.

F. Specify to the printer the number of sheets, the type of paper, and the color. You might have the floral stationery printed in rose or purple ink.

G. The same procedure applies for envelopes.

A Calligrapher's Apron

It's wonderful to be able to identify and personalize the very fabric of your existence, including the shirt off your back. With the advent of the waterproof magic marker this becomes a remarkably easy and impressive feat. You can write on all kinds of fabric and vinyl-like materials, including pillows, aprons, canvas bags, dresses, deck cushions, life preservers, T-shirts, hats, umbrellas, scarves, and sheets.

Let's make an apron for calligraphy. An apron is a very nice and practical gift for whoever you think might be able to use one. You can use it for cooking, gardening, or working in the shop.

SUPPLIES

1. A light-colored muslin or canvas or cotton apron that you have made or bought. Test a corner of the fabric with a waterproof

magic marker to make sure that the writing will not "feather" or "bleed."

2. Broad-edged felt-tip marker. I find that the color black yields the best results.

3. Fine felt-tip marker (to letter the text in skeletal form and draw the illustration).

4. 2H pencil.

5. Ruler.

6. Tracing paper (16″ × 18″) from a roll or pad.

7. ¾″ masking tape.

8. Graphite paper (art store). Or you can make some by rubbing the side of a pencil on one side of a large piece of paper until it is coated with graphite.

PROCEDURE

A. Determine on paper the area of your apron design. (Mine is 16″ × 18″.) You might want to trace John Tenniel's drawing from *Alice's Adventures in Wonderland*, which we've included. Or else allot the space for an illustration you want to draw.

B. Make a pen scale for your broad-edged marker. The traditional scale for uncial is 5 pen widths, but I made it 4 pen widths to convey the fat, round feeling of Humpty Dumpty.

C. Draw guidelines on the 16″ × 18″ paper and begin to calligraph with your markers.

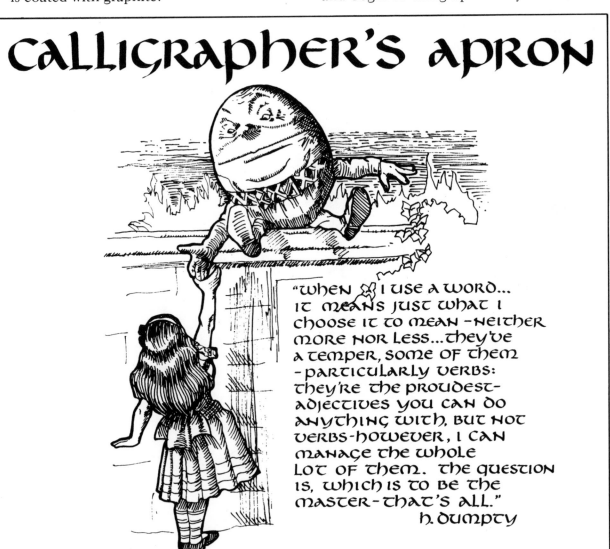

CALLIGRAPHER'S APRON

"WHEN ✱ I USE A WORD...
IT MEANS JUST WHAT I
CHOOSE IT TO MEAN –NEITHER
MORE NOR LESS...THEY'VE
A TEMPER, SOME OF THEM
–PARTICULARLY VERBS:
THEY'RE THE PROUDEST-
ADJECTIVES YOU CAN DO
ANYTHING WITH, BUT NOT
VERBS-HOWEVER, I CAN
MANAGE THE WHOLE
LOT OF THEM. THE QUESTION
IS, WHICH IS TO BE THE
MASTER-THAT'S ALL."
H. DUMPTY

Remember the proper pen angle when working with a broad-edged nib and the uncial hand.

D. Spread the apron flat on a smooth surface, such as a tabletop, and tape down the corners with masking tape. Pencil an outline of the drawing, guidelines, and the lettering on the cloth.

E. Pencil a sketch of the drawing, or lay the tracing paper, with a piece of graphite paper face down underneath, on top of the material and retrace the drawing.

F. Letter and draw the illustration with the marker.

G. Let the ink dry for a few hours and then either erase the pencil marks lightly or throw the apron into the laundry.

chapter 4

CAROLINE

The king, our Emperor Carlemaine,

Hath been for seven full years in Spain,

From highland to sea hath he won the land;

City was none might his arm withstand;

from the Song of Roland

The Caroline style is a Renaissance adaption of the Carolingian, a style prompted at the turn of the ninth century by Charlemagne, who wanted a consistent writing design throughout the Holy Roman Empire. The influence of the uncial style is still evident. Today the Caroline style is used for most typeface designs in books and newspapers.

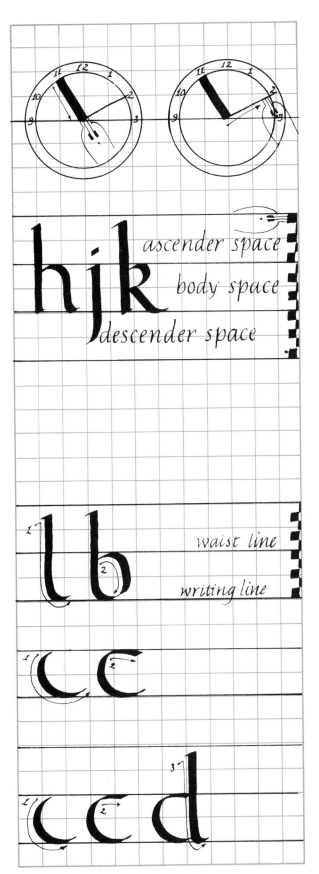

Pen Angle

Caroline works well with the Roman majuscules to create a majuscule/minuscule system. For this reason, it is written at a 30-degree angle to the writing line.

Letter Height

The Caroline style has a lot of ascenders and descenders. The height of the ascenders is generally five nib widths, the height of the descenders is three, and the height of the body of letters is five pen widths (same as the uncial).

Basic Strokes

Let's begin with letters having rounded shapes. The B begins with an ascender that comes straight down almost to the writing line before curving to the right. A curved stroke then departs from the stem to meet the waist line before curving down and around to meet the hairline of the first stroke.

The first stroke of the C, beginning at the waist line, is extremely round. The second stroke is somewhat flat and to the right.

The first two strokes of the D form a C. The vertical ascender stroke touches the ends of the first two strokes on its way to the writing line.

The O is extremely round; the outer perimeter should be as near to a perfect circle as you can make it.

The first two E strokes are the same as the O except that the second stroke stops shortly after beginning its descent from the waist line. The third stroke departs from the first stroke slightly above center and angles up a bit to meet the end of the second stroke. Check the angle of your nib to keep this last stroke from becoming a hairline.

The P begins at the waist line and drops below the writing line to form a descender. A second stroke similar to the second stroke of the B follows, and the letter is finished at the writing line with a horizontal as shown.

The Q begins with a C and finishes with a descender.

The first stroke of the N is a vertical. The second stroke begins as a hairline that curves up to the waist line, curves back down, straightens and then turns out to the right at the writing line.

The M is similar to the N, except that the curves should be tightened to keep the letter from spreading out of proportion with the rest of the alphabet.

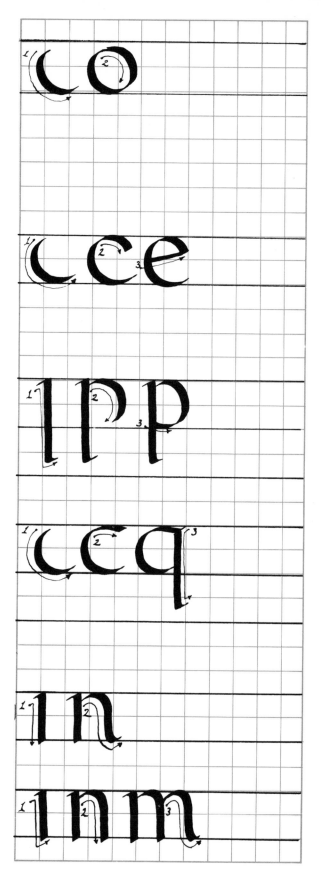

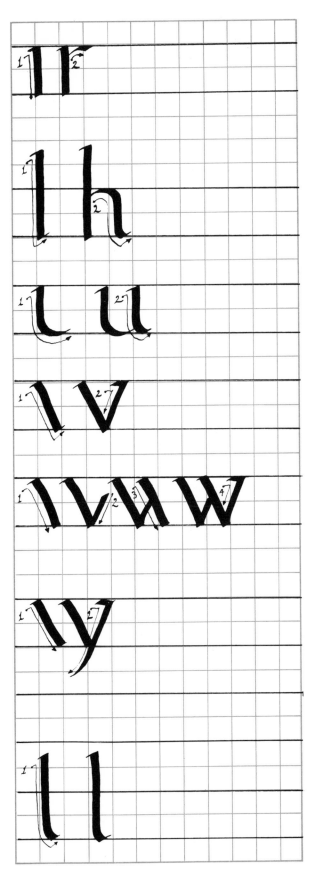

The R starts as the N did, except that the second stroke flattens at the waist line before stopping abruptly.

The first stroke of the H begins at the top line to form an ascender. The second stroke is like that of the N.

The U is an inverted N.

The diagonals are next. The V and W are made the same as their Roman majuscule ancestors, except shorter.

The Y begins as the V did. The second stroke is a diagonal that doesn't quite reach the drop line.

The L is a simple vertical stroke that turns to the right at the writing line.

The I begins at the waist line and turns to the right just before the writing line. The "dot" over the I should be small and unobtrusive—merely a visual clue to identify the letter.

The same applies to the J.

The K has three strokes: an ascender, a bowl and a diagonal to the right.

The S, X, and Z are made the same as the Roman majuscule forms, except shorter.

The T is a vertical that starts just above the waist line (not in a true ascender) and curves to the right just before the writing line. Notice that this curve is rounder than the ending of other letters. A short horizontal at the waist line finishes the letter.

The F is a letter with a curved ascender, a second stroke that extends the curve to the right, and a horizontal stroke in the manner of the T.

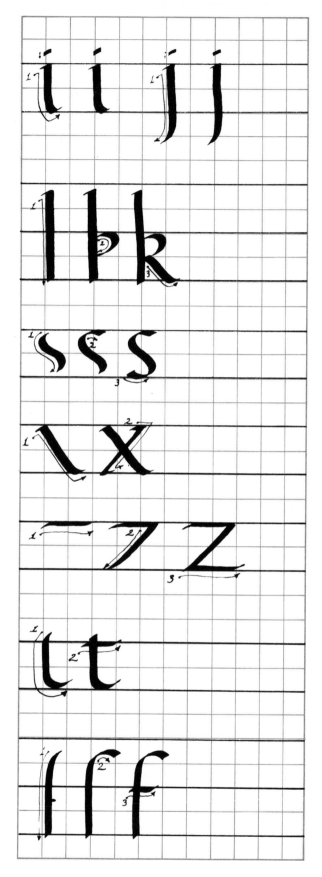

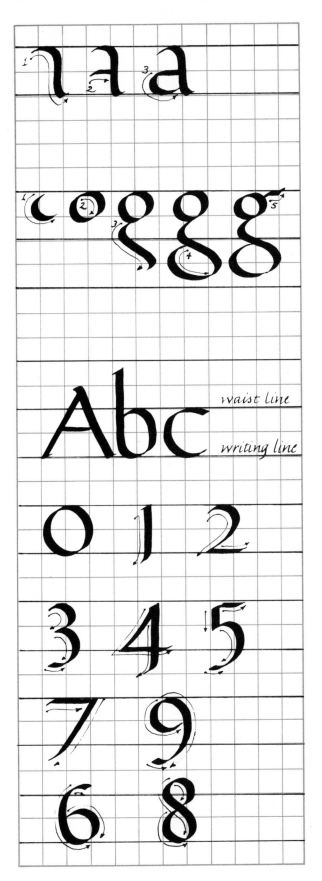

The first stroke of the A is the same as the second stroke of the N. To form the bowl, make a short stroke that travels to the right to meet the first stroke slightly below center, and make another stroke from the hairline of the previous stroke down and back to the right to meet the first stroke again on the hairline.

The G is begun with a small O shape hanging down from the waist line. The second stroke completes the circle. The third stroke is like the first S stroke, curving down to the left and then to the right, beginning and ending on a hairline. The fourth stroke completes a bowl beneath the writing line. The last stroke is the little tail.

Roman majuscules work well with the Caroline style to make a good upper-case/ lower-case set. Roman majuscules written at a height of 7½ or 8 pen widths and the Caroline style written at 5 pen widths will give you capitals that are about one and a half times as high as the small letters—an ideal proportion. Note that this means the ascenders of the Caroline letters will be taller than the capitals.

The Arabic numerals adhere to the Caroline style.

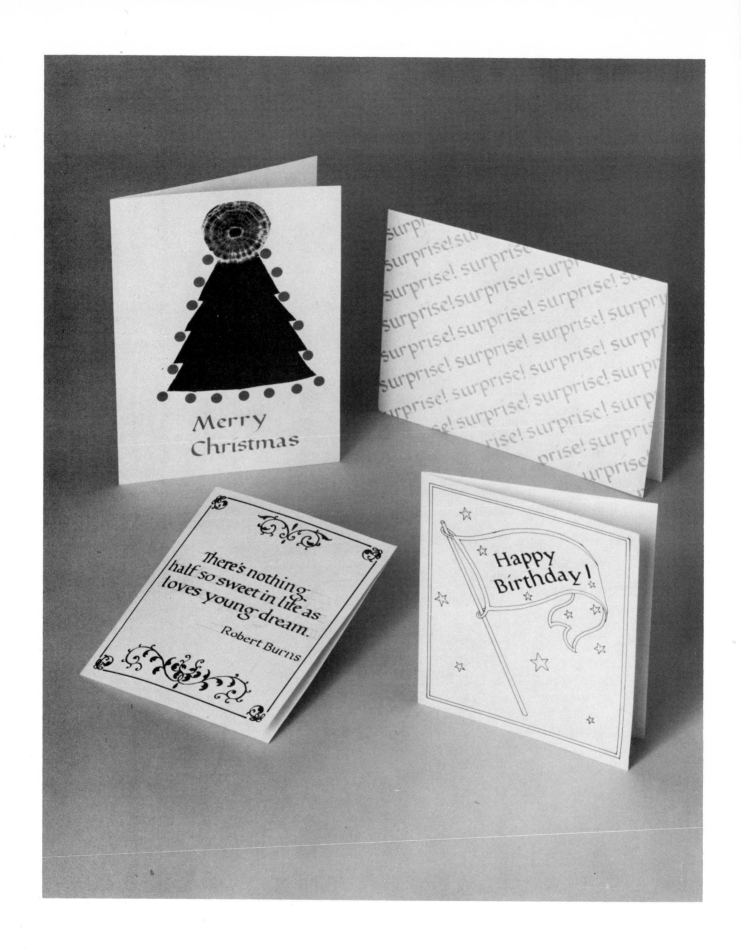

CAROLINE PROJECTS

Greeting Cards

Cards are perhaps the most frequent way to express our feelings toward someone on a special occasion. Handmade cards restore an intimacy that is lost in mass-produced items and enable you to choose a quotation or phrase that is particularly appropriate. (If you discover a design you like particularly well, you might have a batch printed for Christmas or some other occasion.)

SUPPLIES

1. Bond paper (it folds, is easy to work with, takes ink well, and has an ideal weight for cards).
2. Fine-tip felt marker.
3. Rubber cement: the small jar or can with the brush in the cap (for "Merry Christmas" card only).
4. Rubber-cement pickup to remove extra rubber cement (for "Merry Christmas" card only).
5. Colored paper (for "Merry Christmas" card only).
6. Fountain-pen lettering set with fountain-pen ink in whatever color you like.
7. If you want to letter with opaque colors, use gouache, a water-based paint available as Winsor and Newton Designers colors; a dip pen; a plastic palette with wells; a water container; and a small brush.
8. 2H pencil.
9. Plastic magic eraser.
10. Envelopes (5″ × 7″) for cards.

PROCEDURE

A. Work your message on a practice pad.
B. To make the "Merry Christmas" card, punch out the little red holly berries with a hole puncher. Have fun with the paper and see what comes from play. Paste down the interesting shapes with the rubber cement, let dry, and remove the excess.
C. Arrange the practice lettering on top of your shapes and transfer your guide marks carefully. Pencil in the message lightly.
D. Now letter. It looks nice to have dark letters on a light area and vice versa. If you letter with gouache, squeeze a little paint into a plastic palette and mix with water until it has a consistency of light cream. Paint the nib with a brush (never dip a nib into paint) and letter. If the paint seems to bead on the paper, add a drop of liquid dish-washing detergent to the mixture.
E. Draw or trace your borders with a fine-tip felt marker.

Birth Certificate

The Pennsylvania Dutch gave me the inspiration for a birth certificate. Made with a floral border in the shape of a heart like one of their "Fraktur" pieces, it has an old feeling about it and yet is as contemporary as the people you are making it for. The design is suitable for a wedding or any other occasion.

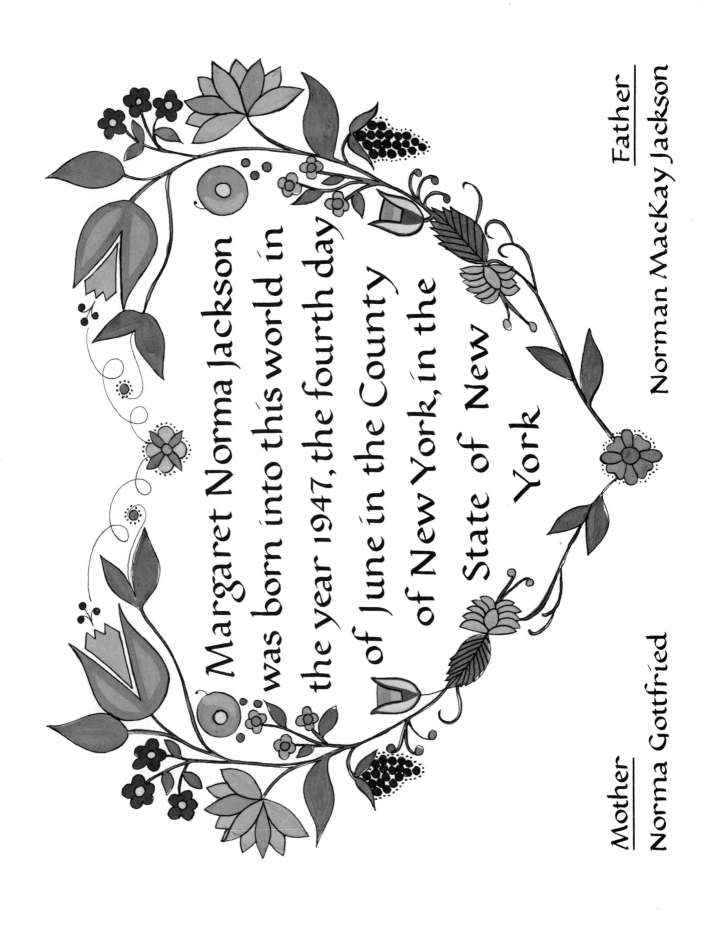

Margaret Norma Jackson was born into this world in the year 1947, the fourth day of June in the County of New York, in the State of New York

Father
Norman MacKay Jackson

Mother
Norma Gottfried

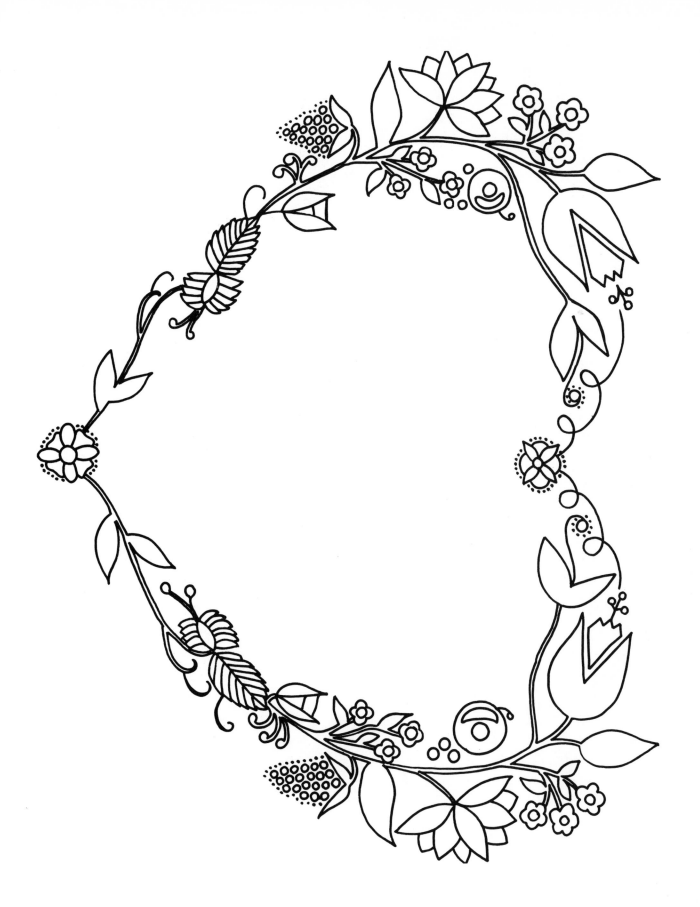

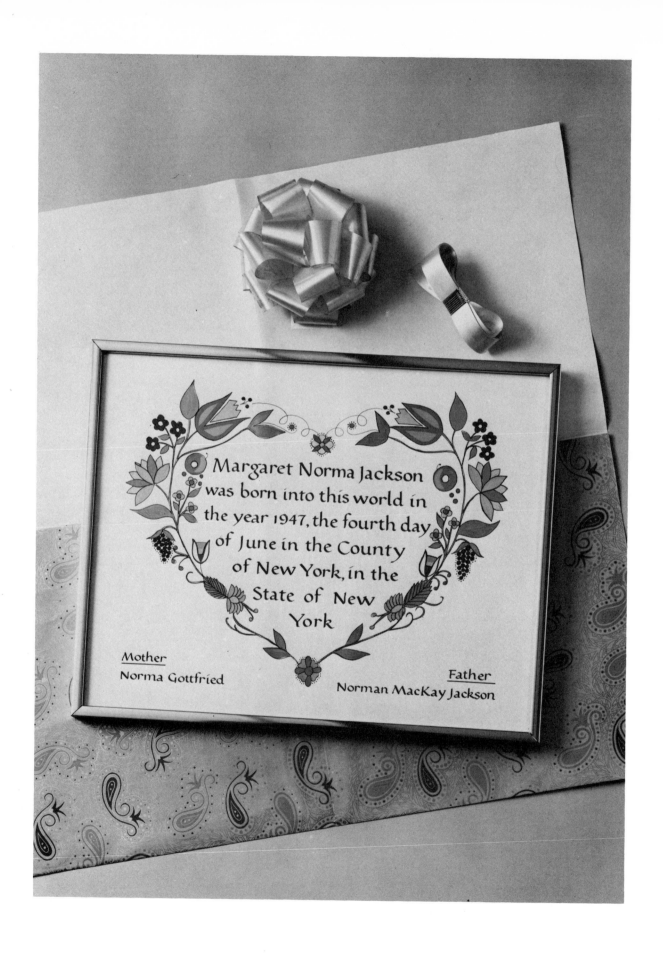

Margaret Norma Jackson
was born into this world in
the year 1947, the fourth day
of June in the County
of New York, in the
State of New
York

<u>Mother</u>
Norma Gottfried

<u>Father</u>
Norman MacKay Jackson

1. Paper for the certificate.
2. Tracing paper (11″ × 14″) from a roll or pad.
3. Graphite paper, or you can make your own by rubbing the side of a pencil on one side of a large piece of paper until it is coated with graphite.
4. 2H pencil.
5. Ruler.
6. Plastic magic eraser.
7. Gouache, a water-based paint, available as Winsor Newton Designers Colors.
8. Small brush.
9. Plastic palette with wells.
10. Water container.
11. Fountain-pen lettering set.
12. Any fountain-pen ink.
13. To outline you will need a crowquill dip pen (size B-4) and a holder.
14. Scrap paper.

PROCEDURE

A. Enlarge the border outline to any size that you wish. (You may do so with tracing-paper grids or by having a photostat enlargement made.) Slip the graphite sheet (graphite side down) under the paper drawing, and trace the design with your pencil to the birth-certificate paper.

B. Mix your colors in the palette until your paint has the consistency of light cream. We are going to outline them later. Let paint dry thoroughly.

C. To outline the flowers: Test your crowquill and black ink on a piece of scrap paper before you outline the flowers. Outline and let dry thoroughly.

D. Transfer the shape of the inner portion of the heart from the original tracing paper onto a piece of scrap paper. Pencil ruled lines inside the heart and see if your text fits. If it doesn't, sketch a few hearts to determine the size you want. Draw pencil lines on the lower right and left for the names of the mother and father. Rule lines on the birth-certificate paper very lightly and letter with gouache, making sure to paint the nib with a brush (never dip a nib into paint). When the ink is dry, erase the pencil lines gently with a plastic magic eraser.

chapter

5

GOTHIC

Reminiscent of Gothic architecture, the Gothic script lends itself to rich decoration with a vertical appearance dominating the design.

Scribes still wrote on animal skin during the Middle Ages, but because of the cost and the time to prepare it, they attempted to fit more letters and words onto a line and more lines onto a page. The emerging Gothic style, known also as black letter (because of the density of its appearance), Old English, and Fraktur, condensed the Carolingian style into a very angular and vertical design. As-cenders and descenders were shortened to allow for less room between lines. But as space was saved, legibility suffered; the Gothic style is extremely decorative and pretty to look at, but hard to read. It has limited practical use, but works nicely for invitations, testimonials, and, as we have sampled here, dinner menus.

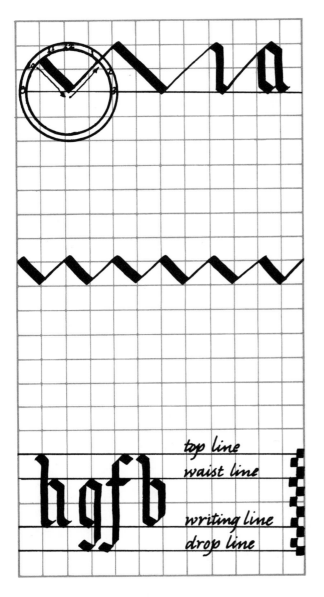

Pen Angle

The Gothic style is written entirely at a 45-degree angle. Hold your pen at 10:30 on the clock and draw it to the center. Your pen at 45 degrees will make the fattest stroke. Now draw your pen up and to the right on the hairline, still at 45 degrees, arriving at 1:30.

A good way to check your angle is to work within a square on your graph paper. With your pen at the upper left corner of one square, make a stroke down to the lower left corner of the same square and (without lifting your pen) up to the upper right corner. The downward stroke should be the fattest and the upward stroke should be a hairline. Practice the sawtooth pattern.

Letter Height

Gothic letters, like uncial and Caroline, are written at a height of five nib widths. The difference is that the ascenders and descenders have a height of two and a half nib widths, rather than five as in the Caroline style. Make Gothic majuscules (not shown here) at a height of seven nib widths.

Basic Strokes

Three basic strokes, two short diagonals and a vertical, form most of the Gothic letters. Try a few of them.

Notice that you have made a line of I's. Make the "dot" with a short hairline.

Two of these basic strokes together, connected only at the top, make an N.

Three strokes make an M.

Two strokes together, connected only at the bottom, make a U.

An elongated stroke will give you an L. Keep in mind the proper ascender height.

An elongated stroke and a stroke of regular height make an H.

A basic vertical stroke and a short diagonal stroke make an R.

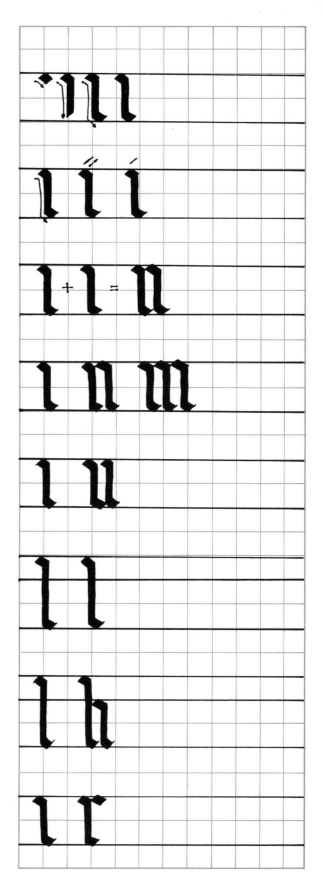

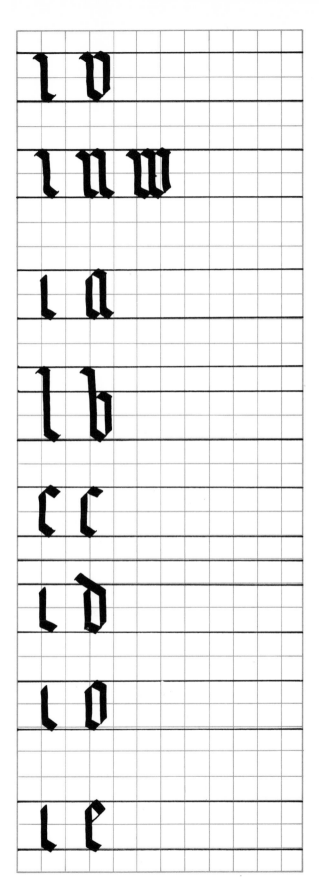

A basic vertical and the first two strokes of another vertical give you a V. Notice that the space between the two strokes is closed at the bottom and open at the top.

The W is made the same as the V except that two vertical strokes instead of one are drawn before you make the last stroke.

Continue to make letters, keeping in mind the basic strokes.

The E, like the O, begins with a basic vertical and a short diagonal. It continues with another short diagonal at the waist line and ends on a hairline.

The F is unique in that it has an ascender and a descender.

The G begins as the O did. The second stroke starts on a short diagonal and breaks through the writing line to form a descender. The last stroke is a short diagonal at the bottom of the second.

The J descends like a basic stroke below the writing line, but instead of ending with a diagonal, it veers to the left on a hairline. The dot is the same as in the I.

The K looks tricky: lots of strokes to fit into a small space. First, make an ascending stroke. Then, at the waist line, make a short diagonal. Directly underneath and again touching the first stroke, make another complete basic stroke, shortened considerably, to finish neatly at the writing line.

Continue with the P and Q after my example.

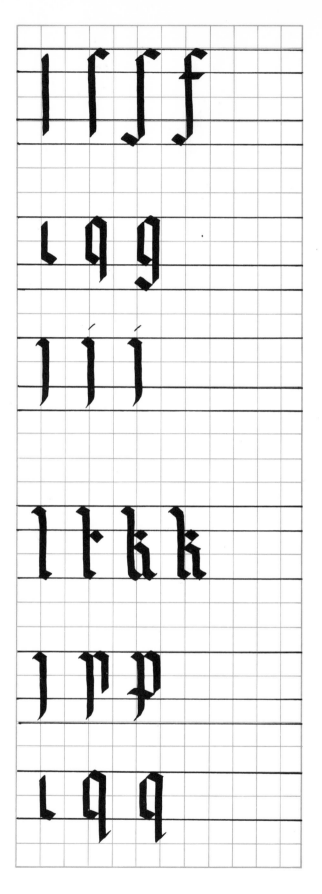

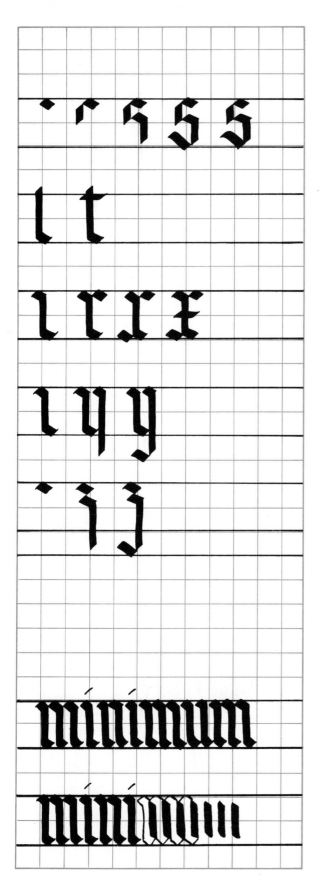

Take the S one step at a time and you should have little difficulty. Keep in mind that you are still using a variation of the basic stroke, but, as in the K, your strokes have to be shortened to make everything fit into the allotted space.

The first stroke of the T, as in the Caroline style, starts slightly above the waist line.

Finish the last few letters of the alphabet after the example.

Spacing

Spacing is essential to achieve the rich, dark vertical design of the Gothic script. The amount of space between the strokes and the letters must be equal. If the letters are spaced properly, the word will look like a picket fence.

Look at the word "minimum." All the letters in the word are made up of the three basic strokes. When you repeat the basic stroke of this word, the space between the strokes is also repeated.

The general rule of thumb still applies: leave enough space between words to fit an O.

The Arabic numerals and punctuation, to accommodate the Gothic letters, are angular and vertical.

Gothic majuscules are written at a height of seven nib widths.

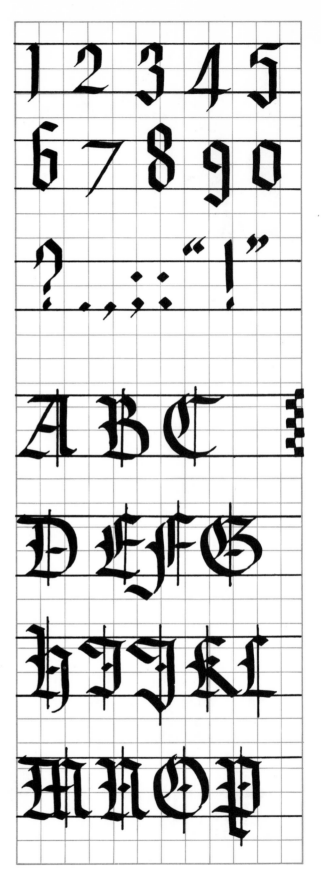

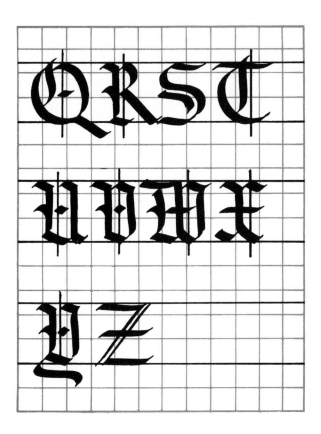

GOTHIC PROJECTS

Dinner Menu

You might want to do something special when the boss, the in-laws, or friends are coming over for dinner. If you have some occasion that necessitates fussing, then it's fun to make a dinner menu for a private dinner. For this example let's make one to put in the center of the table rather than individual ones for everyone.

SUPPLIES

1. Paper for the menu: poster board or thin cardboard, called Bristol board.
2. Fountain-pen lettering set.
3. Fountain-pen ink.
4. Fine-point felt marker.
5. 2H pencil.
6. Plastic magic eraser.
7. Ruler or T-square.

PROCEDURE

A. Determine what will be on the menu and cut an appropriate size from the Bristol board.
B. Trace the lines of the border and fruit bowl in pencil and then draw with a fine-point felt marker. Let dry thoroughly and erase pencil marks.
C. Work out a rough lettering of the menu

items on scrap paper. Cut up the paper and arrange each item on the menu board until the design pleases you.

D. Pencil guidelines and the menu items onto the board in the appropriate places.

E. Letter the menu in black ink. Let dry thoroughly and erase pencil marks.

Place Card

Personalize each person's table setting with a name place card. You might want to try this project for a special dinner party, or simply make the cards for your family.

SUPPLIES

1. Paper for the place cards: poster board or thin cardboard, called Bristol board.
2. Fountain-pen lettering set.
3. Fountain-pen ink.
4. 2H pencil.
5. Plastic magic eraser.
6. Ruler.
7. Fine-point felt marker.

PROCEDURE

A. Cut the appropriate size (folded, 1⅞″ × 3″) from the Bristol board.

B. In pencil, trace the lines of the border and a writing line.

C. Letter the name in ink and draw the border with the fine-point felt marker. Let dry thoroughly and erase pencil marks.

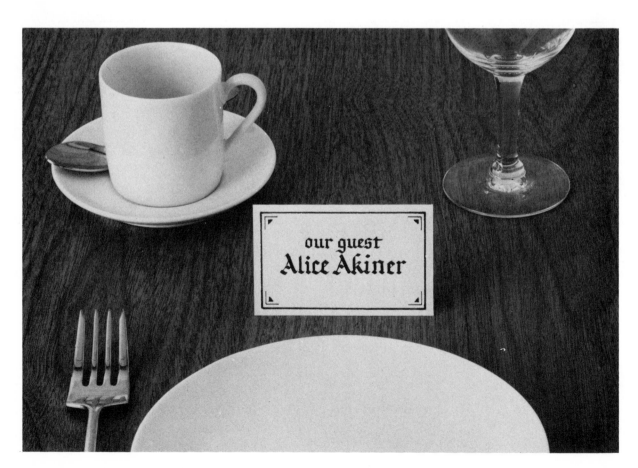

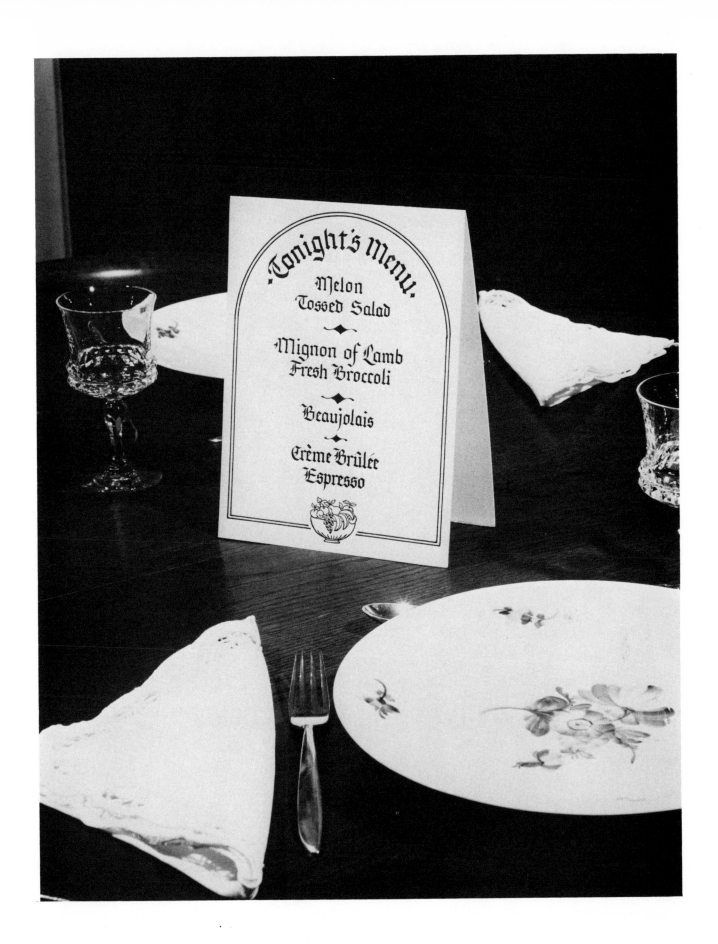

Tonight's Menu.

Melon
Tossed Salad

◆

Mignon of Lamb
Fresh Broccoli

◆

Beaujolais

◆

Crème Brûlée
Espresso

Family Tree

This project was the most fun; I found some interesting characters among the Arnolds. A family tree is always a treasured heirloom and a very special gift to make for someone.

SUPPLIES

1. Paper for the family tree.
2. Crow-quill pen.
3. 2H pencil.
4. Plastic magic eraser.
5. Ruler or T-square.
6. Fountain-pen lettering set.
7. Fountain-pen ink.

PROCEDURE

A. Make a list of your ancestors and any pertinent information. Libraries and genealogical societies will usually be helpful to your research.

B. Gather the information you want to include and trace our actual-size pattern of the family tree with a crow-quill pen, which will make very thin lines.

C. Pencil in lines for lettering.

D. Letter with ink all the information. Let dry thoroughly and erase the pencil marks with a plastic magic eraser.

E. Frame.

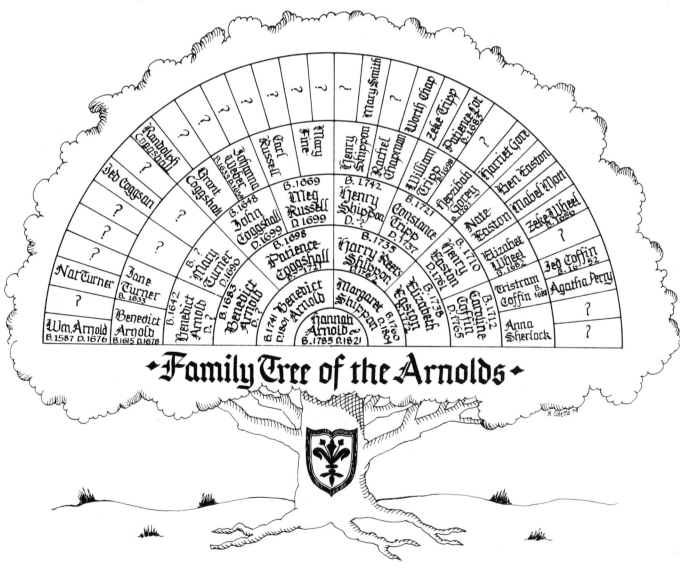

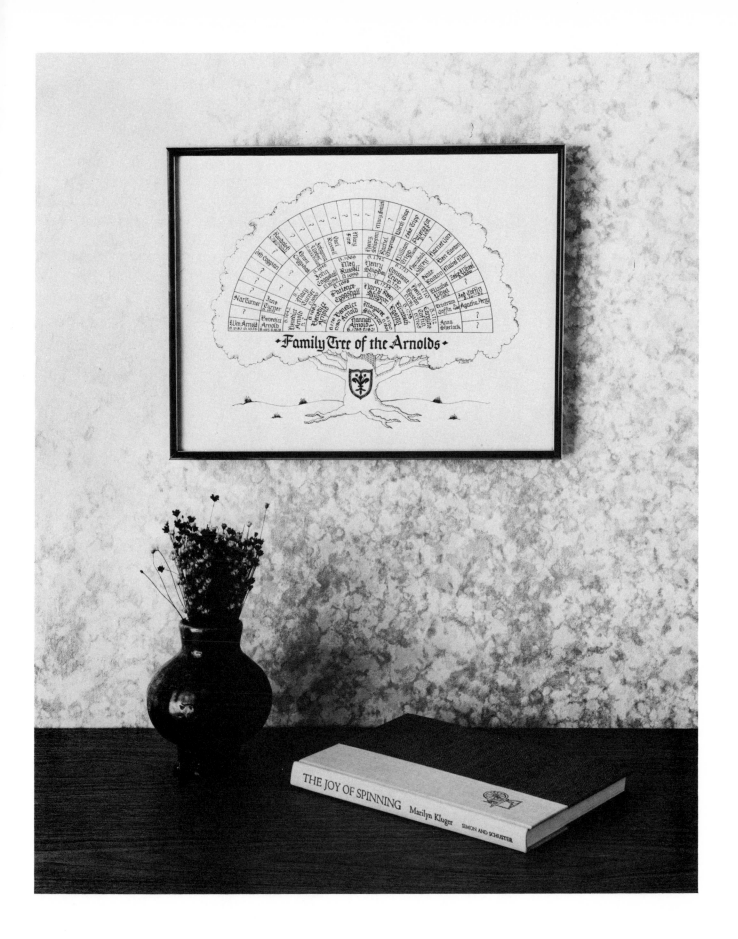

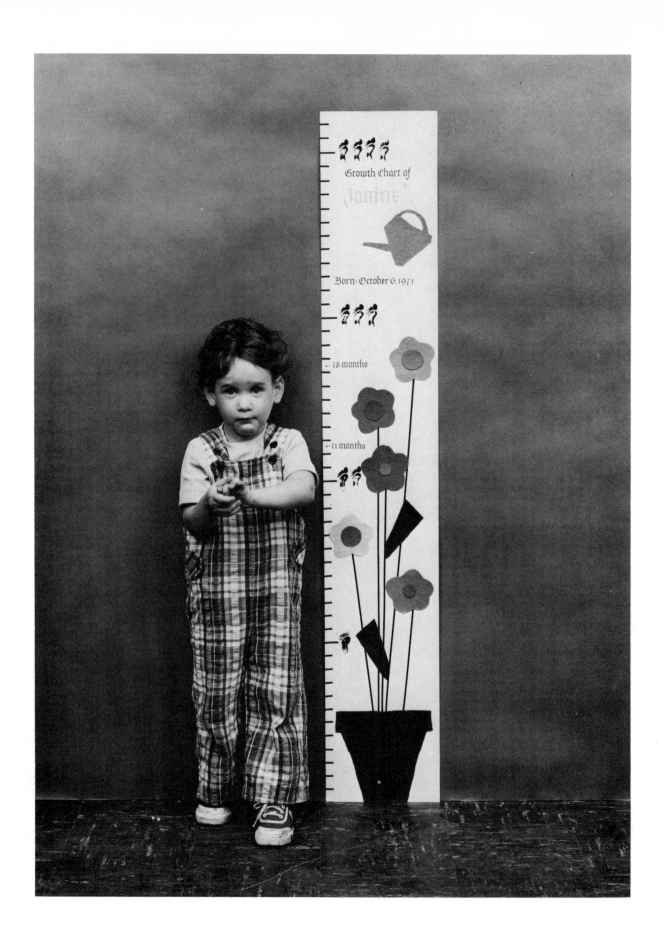

Growth Chart

Watch the children and the flowers grow. Children will love to measure their growth next to the colorful flowers and be delighted to outstrip them. Your elegant black-letter entry of data alongside will make the chart a treasured heirloom of the child whose name it bears.

SUPPLIES

1. Dip-pen set.
2. Graphic-art tape, ⅛″ roll in matte black.
3. Colored felt squares.
4. Scissors.
5. Library paste.
6. Ruler.
7. 2H pencil.
8. Plastic magic eraser.
9. Gouache, a water-based paint, available as Winsor and Newton Designers Colors.
10. Plastic palette with wells.
11. Water container.
12. Small brush for mixing paint.
13. Piece or roll of paper, at least 50″ long and 8″ wide, that will accept ink without bleeding. Try butcher paper or paper from copy machines and from art stores.
14. Masking tape.
15. Soap eraser.
16. Razor blade (single-edged) or X-acto knife.
17. India ink.

PROCEDURE

A. Tape down the edges of your paper to a large, flat surface.
B. Use the graphic-art tape to make inch marks along the paper from the bottom up with lines that are ½″ long. Denote each foot with an inch-long line.
C. Draw the outline of a foot on one flat surface of the soap eraser and cut away the rest of the surface with a razor blade to make a stamp imprint of a raised foot.
D. Make a small smear of ink and practice the imprint on scrap paper before you stamp the chart (one foot at 12″, two at 24″).
E. For the flowers, draw (in pencil) five roundish petal shapes on the different-colored pieces of felt. Make small circles the size of quarters and nickels for the centers. Cut them out with a scissor and turn them over so the pencil marks do not show.
F. Place the felt shapes on the chart. Next cut out a flowerpot shape and place that at the base of the chart. Do not paste them down yet.
G. Take tape and stretch from flowerpot to flower, making sure it reaches under both. Do this for each flower.
H. Now paste down the flowers and the flowerpot over the tape with library paste. Be careful to paste the edges down but not to have paste coming out at the sides.
I. Letter the child's name on scrap paper using the proper pen scale and a very large nib. Then move the scrap paper around until you find a spot where it looks good. When you are satisfied, draw lines and letter the name in pencil on the chart.
J. Mix the gouache with water until it is the consistency of light cream and then paint the nib with a brush dipped in the mixture (never dip a nib into paint). Test on scrap paper and letter on the chart. When the ink is dry, erase the pencil lines gently with a plastic magic eraser.

chapter **6**

ITALIC

The need during the Renaissance for a writing style that was easy to read and write established the Italic style of writing.

The Italic was the first style to be written at a slant. The minuscules bear a strong resemblance to the Caroline style (also popular during the Renaissance), and the majuscules are derived from the Roman majuscules.

Pen Angle

The pen angle is 45 degrees, the same as for the Gothic.

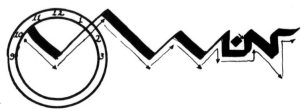

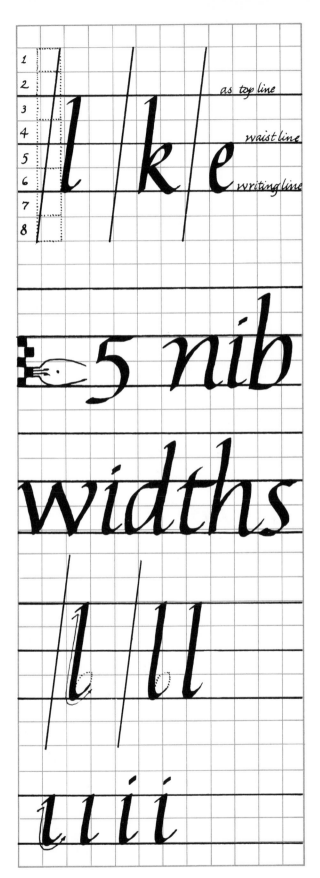

The slant is at an angle of 8 to 10 degrees from a vertical stroke. On your graph paper count eight squares down and one square across, draw a line from the upper right corner of the column to the lower left corner, and you have the proper slant. Practice these slanted vertical strokes. Notice that when you curve to the right at the writing line, the shape you describe is now elliptical rather than circular. This elliptical shape will reappear throughout the alphabet.

Letter Height

The body of the letters is written at a height of five nib widths. Ascending strokes are ten nib widths, and descending strokes are a bit less.

Basic Strokes

The L is a basic ascending vertical stroke. Remember to make the elliptical shape at the writing line.

A short vertical with a dot makes the I.

Not a true ascender, the T begins just above the waist line.

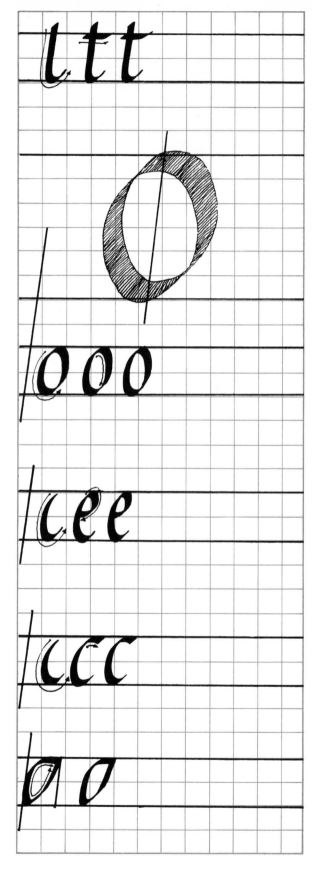

The O, a basic elliptical shape, is made with two strokes that both begin and end on a hairline.

The first stroke of the E is similar to that of an O. The second stroke curves down and into the first stroke slightly above center.

The C also begins like the O, and the second stroke flattens at the waist line before it stops abruptly.

Most of the remaining Italic letters are constructed within the borders of an oblong parallelogram. Here we face a new basic shape. Beginning in the upper right corner of the parallelogram, push the pen to the left along the waist line at a 45-degree angle, pull the pen down the left edge, curve the stroke at the writing line, and push the pen back up to the starting point.

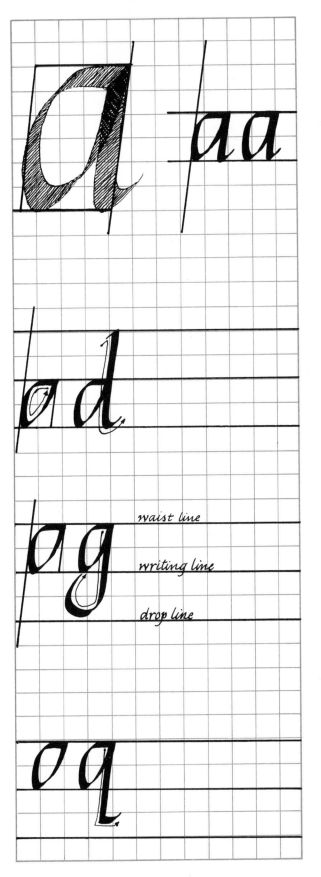

To make an A, continue at the top right corner with a pen stroke down the right edge and into an elliptical curve at the writing line. Note how this stroke overlaps in the upper right corner.

Making the shape again, lift your pen after you close the form, and start at the top line with a stroke that is like an L, overlapping the first form as you did in the A. You have completed the D.

waist line

writing line

drop line

Make the basic shape again and pull the stroke down from the waist line to form a descender. Nearing a drop line, pull the pen around to the left and back up to meet the body of the letter. This will give you a G.

Starting again with the basic shape, pull the pen straight down from the starting point to form a descender. Stop abruptly and kick the pen to the right, completing the Q.

To make the N, start at the waist line with a small elliptical curve and come down the left side of the parallelogram to the writing line. From there, push the pen to the upper right corner and curve the stroke back down along the right edge to the writing line. Finish with a small elliptical curve.

To draw an H, make the first stroke an ascender and finish the letter as you did the N.

Begin the R as you did the N. As in the Caroline style, the second stroke is flat on top.

Double the N shape to draw the M. Tighten the curves a bit to keep the letter from spreading into an eyesore.

This next shape begins at the lower left corner, travels to the upper right corner, down the right edge, and back to the beginning.

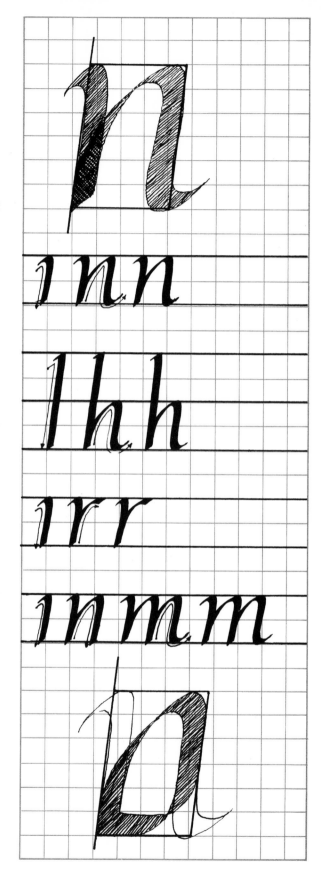

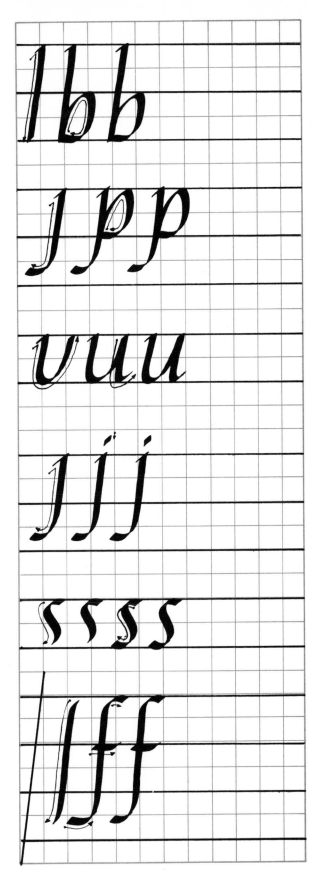

Make the B with an ascender and this new shape.

The first stroke of the P descends below the writing line before it curves to the left. The second stroke is the same as the bowl of the B.

Beginning the U with a serif, pull the stroke down, around, and up. The second stroke is pulled down to the writing line and ends with an elliptical curve.

The J is a descender stroke that curves to the left below the writing line. Don't forget the dot.

The S is a slow letter to make. Begin with the push of the pen to the left along the waist line and then curve it down and to the right. This downward stroke, as in the Caroline style, should be curved at the top and bottom, but should remain fairly straight in the middle. Finish the letter with another push to the left along the writing line.

The F is unique in that it is the only letter with both an ascender and a descender.

The K begins as the B did, except that the second movement meets the waist line and then curves back to meet the stem above center. From there you can pull the pen down on a diagonal to complete the letter.

To make a V, pull the stroke down from waist line to writing line and back up again.

You can make the four strokes of the W without lifting the pen from the paper. Complete the last stroke as you did for the V.

The X begins with a diagonal stroke from the waist line to the writing line. The second stroke begins with a short push to the left before falling into a diagonal that crosses the first stroke slightly above center and ends with another short push to the left.

The Y is completed in two strokes, the first being a diagonal and the second a descender as shown.

The Z is made with three movements.

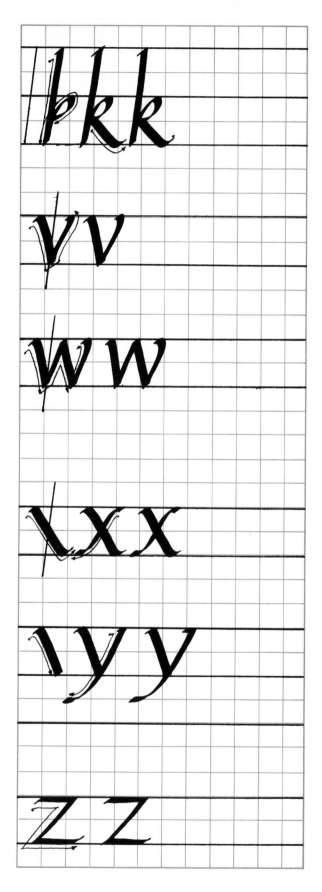

ABCDEFGH
IJKLMNOPQ
RSTUVWXY
Z

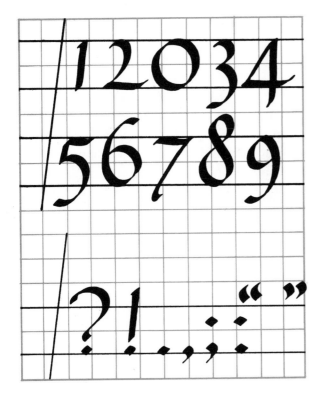

Italic Majuscules

Italic majuscules have the same basic linear form as the Roman majuscules. They are written at a constant 45 degrees to the writing line and on a slant of 8 to 10 degrees.

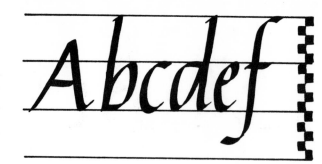

The height of Roman majuscules is measured at seven and a half nib widths.

not like this

not like this

Flourishes add an elegant touch to the Italic capitals, but they should be used sparingly. Remember that they are simply extensions of the basic strokes of letters and should not interfere with the body of the letter.

ABCDEF

GHIJKLM

NOPQRST

UWVXY

Z

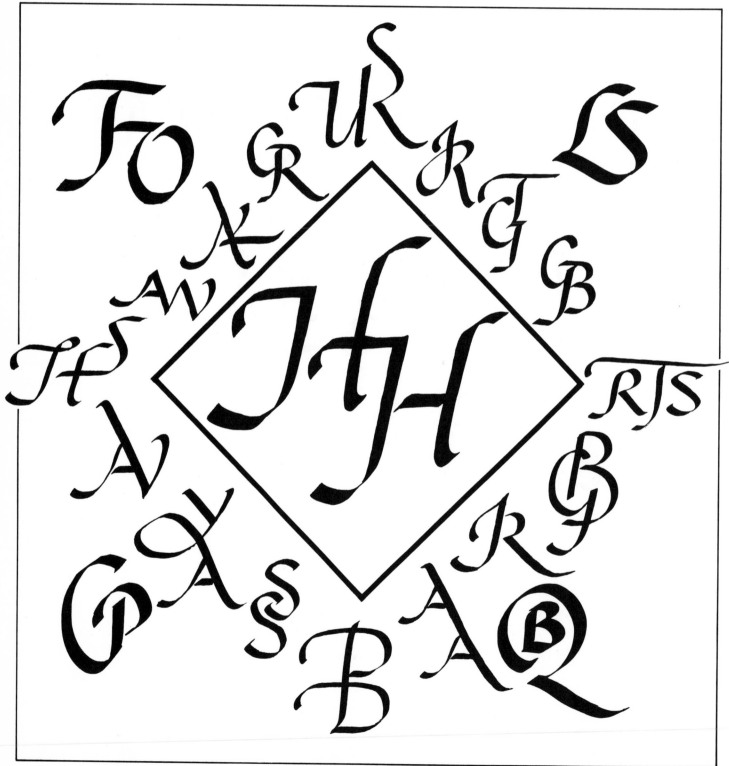

ITALIC PROJECTS

Monogram

A monogram is a design formed by a combination of letters, usually the initials of someone's name. You can use a monogram to personalize your clothes, belongings, books, art, and letters.

SUPPLIES

1. Scrap paper.
2. Fountain-pen lettering set.
3. Fountain-pen ink.
4. India ink, if you are preparing the design for reproduction.
5. Permanent magic marker if you plan to write on fabric.

PROCEDURE

A. The trick to making a distinctive monogram is in the inherent letter forms. Find strokes that the letters have in common and could possibly share. Play with the combinations until a design evolves. For example, A and V have in common a diagonal stroke from left to right, top to bottom.
B. Use any fountain-pen ink to put your monogram on individual note cards, calling cards, stationery, or bookplates.
C. Use permanent magic marker to personalize deck cushions, pillows, laundry bags, aprons, and sail bags.
D. Use India ink if you want to put the monogram on stationery and have copies made at the printer's (see instructions for stationery, p. 42).

Monograms can be used on:
Stationery
Seats of chairs—either needlepointed
 or merely written in magic marker
Pillows
Wedding invitations
Business cards
Life preservers
Scarves
Place mats
Shoes
Canvas bags
Handbags
Gloves
Towels
Books
Memo pads

Mood Poster

Everyone has a phrase or a few words that he finds especially meaningful. A wonderful present is to give someone his favorite saying or quotation in poster format so that he can hang it up and read it every day. It serves as inspiration and as a guidepost for the emotions.

SUPPLIES

1. Bond pad, 11″ × 14″.
2. T-square.
3. 2H pencil.
4. Plastic magic eraser.
5. Fine point marker.
6. Fountain-pen lettering set.
7. Fountain-pen ink (any color you like).

Love

By the accident of fortune
a man may rule the world
for a time

but by the virtue of love
he may rule the world
forever.

Lao-Tse

PROCEDURE

A. Determine the nib size of your pen by the amount of text. If you have roughly the same amount of text as we have, try a B-3.

B. Trace the design of the scroll.

C. Pencil in your writing lines and the message.

D. Letter your words in ink. Let dry thoroughly and erase pencil marks.

E. Draw outline of scroll with the fine-point marker. Let dry thoroughly and erase pencil marks.

F. Frame the poster or present it as a scroll with a bit of ribbon tied around it.

Wedding Invitations

When the occasion arises for a large gathering, such as a wedding, you might want to thrill and astonish the guests with your calligraphic skills by sending them an invitation that was designed and executed by none other than yourself. You can make one original and have the rest printed. You should find a printer and get samples of what he can print in your price range.

SUPPLIES

1. A nonreproducing pencil, which is a special pencil that will be invisible to the printer's camera (so you don't have to erase), if you are going to take the design to a printer and have copies made.

2. Ruler and T-square.

3. Fountain-pen lettering set.

4. India ink (a very black ink).

5. Cards and envelopes.

PROCEDURE

For a formal wedding, you will need an outer envelope, an inner envelope, the invitation, a response-card envelope, and the response card.

THE INVITATION

A. The size of an invitation is always determined by the size of the envelope. Settle on the size with a printer or stationer. I chose a 5½" × 7" envelope and a 5" × 6¼" invitation.

> *Mr. & Mrs. Gordon Stewart*
> *25 Oak Drive*
> *Chichester, New York*
> *1 0 9 0 6*

B. Arrange the wording and layout of the invitation on scrap paper. You can draw a border or trace one from a magazine or book.

C. Next, transfer the guidelines to the invitation with the nonreproducing pencil. Important: You can make the original layout outsized and the printer can reduce the invitation (and the imperfections!). Just keep the layout in proportion: draw an outline of the invitation's actual size on a large piece of paper and extend a diagonal from the lower left corner to the upper right and beyond. Any box with a corner on that line will be in proportion to the original box.

Mr. & Mrs. Lou Kean
and
Mr. & Mrs. Charles Zaner
invite you to share in the joy of
the marriage uniting their children
Joi Heidi
and
Charles Martin Jr.
on Saturday, the seventh of April
Nineteen hundred & seventy nine
at eight o'clock in the evening
at the Glen Chateau
5619 Glenwood Road
Brookline, Massachusetts

Mr. & Mrs. Gordon Stewart

D. Letter with India ink and take the design to the printer.

THE RESPONSE CARD

A. Again, determine the card size by the envelope size.
B. Proceed as you did with the invitation.

Mr. & Mrs.

will___will not___
attend

Mr. & Mrs. Lou Kean
926 State Street
Brookline, Massachusetts
27968

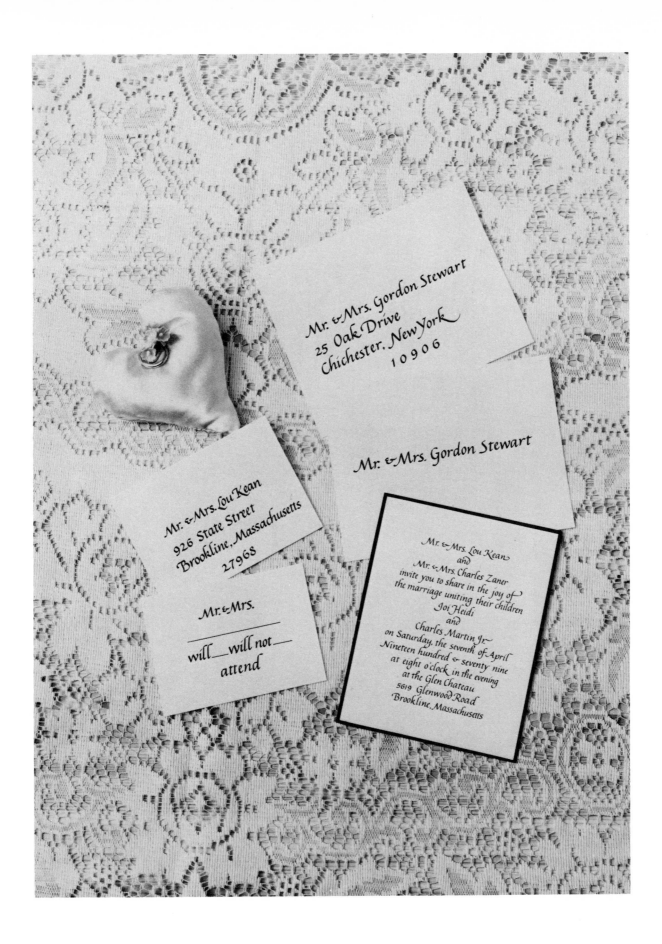

Mr. &Mrs. Gordon Stewart
25 Oak Drive
Chichester, New York
10906

Mr. &Mrs. Gordon Stewart

Mr. &Mrs. Lou Kean
926 State Street
Brookline, Massachusetts
27968

Mr. &Mrs.

will___ will not___
attend

Mr. & Mrs. Lou Kean
and
Mr. & Mrs. Charles Zaner
invite you to share in the joy of
the marriage uniting their children
Joi Heidi
and
Charles Martin Jr.
on Saturday, the seventh of April
Nineteen hundred & seventy nine
at eight o'clock, in the evening
at the Glen Chateau
5619 Glenwood Road
Brookline, Massachusetts

CONCLUSION

Take the skills offered in this book to express
the unique treasures you find while rummag-
ing through your psychic attic. Use them to
make beautiful things that are a source of joy
and creativity.

Glossary

ASCENDER the part of the letter rising above the waist line.

CAROLINE the name of a calligraphic style. This hand was named after Charlemagne, who wanted a spacious and clear letter form. It is also called "white letter" and is the first true minuscule (lower case) hand.

CHARACTER every letter, punctuation, mark, and space between them.

DESCENDER the part of a letter dropping below the writing line.

GOTHIC the name of a calligraphic style. It appeared in Northern Europe during the Middle Ages as a very narrow angular style and, from the density of its appearance, was called "black letter."

HAIRLINE a very slender line, the thinnest stroke possible.

ITALIC the name of a calligraphic style. This hand was developed in the sixteenth century by scribes who wanted a fast, legible, and beautiful hand.

MAJUSCULE an upper-case, or capital, letter.

MINUSCULE a lower-case, or small, letter.

PEN ANGLE The angle of the stroke (made by the pen) to the writing line.

ROMAN the name of a calligraphic style. This hand, made with all majuscules, originated in Greco-Roman times.

SERIF short, thin lines at right angles to the upper and lower ends of the strokes of a letter.

STYLUS a pointed writing instrument such as a pencil.

UNCIAL the name of a calligraphic style. The letters are more rounded and legible than their predecessor, the Roman majuscules. In this hand we see the beginning of the minuscule alphabet.

VERTICAL a line or stroke perpendicular to the horizontal.

WAIST LINE the top line of a minuscule letter (not including the ascender), measured or determined by a specific number of pen-nib widths above the writing line (in Italic, e.g., the waist line is five pen widths above the writing line).

WRITING LINE the line that the majuscule and the minuscule letters sit on.

List of Suppliers

Below is a partial listing of major art stores that carry the supplies you will need. If you live in an area where supplies are difficult to obtain, you can order directly from those stores which handle mail order (see *) or from Pentalic Corporation, 132 West 22nd Street, New York, New York 10011.

ALABAMA

Alabama Art Supply
1006 23rd Street South
Birmingham, Alabama 35205

ARIZONA

Art & Craft Supplies
317 North 1st Street
Sierra Vista, Arizona 85635

Flax Art Materials
4554 North Central
Phoenix, Arizona 85012

ARKANSAS

Lorentz Paint & Wall Supply
1221 Commerce Drive
Mountain Home, Arkansas 72656

CALIFORNIA

Aaron Brothers Art Marts
940 North Orange Drive
Los Angeles, California 90038

M. Flax
10852 Lindbrook Drive
Los Angeles, California 90024

Pas Graphics
1292 East Colorado
Pasadena, California 91106

COLORADO

Art Hardware
1135 Broadway
Boulder, Colorado 80302

H. R. Meininger Company
1415 Tremont Place
Denver, Colorado 80202

CONNECTICUT

Kay's Art Shop
6 Chapel Street
New Haven, Connecticut 06510

Koenig Art Shop
166 Fairfield Avenue
Bridgeport, Connecticut 06604

DELAWARE

Hardcastle & Son
408 Delaware Avenue
Wilmington, Delaware 19801

FLORIDA

Pearl Paint
1033 East Oakland Park Boulevard
Ft. Lauderdale, Florida 33334

Reddi-Arts, Inc.
1037 Hendricks Avenue
Jacksonville, Florida 32207

GEORGIA

Inkpot
3848 Fox Lane Court
Atlanta, Georgia 30319

* Pandora's Box
1635 Phoenix Boulevard, Ste. 9
College Park, Georgia 30349
(*mail order only*)

HAWAII

Stationers Corporation Hawaii, Ltd.
708 Kanoclehua Avenue
Hilo, Hawaii 96720

ILLINOIS

Favor Ruhl Company
14 South Wabash Avenue
Chicago, Illinois 60603

The Flax Co.
180 North Wabash Avenue
Chicago, Illinois 60601

INDIANA

Glass Wonderful World
801 Glendale Boulevard
Valparaiso, Indiana 46383

Hindman's Creative Arts Center, Inc.
Castleton Plaza, Suite 223
6302 East 82nd Street
Indianapolis, Indiana 46250

IOWA

The Art Store
1227 25th
Des Moines, Iowa 50312

Lind's Art Supply, Inc.
9 So. Dubuque Street
Iowa City, Iowa 52240

KANSAS

Color King, Inc.
1401 East Douglas
Wichita, Kansas 67211

LOUISIANA

Dixie Art Supplies, Inc.
323 Magazine Street
New Orleans, Louisiana 70130

MAINE

The Artisans Company
334 Forest Avenue
Portland, Maine 04101

Mac Beans
134 Main Street
Brunswick, Maine 04011

MARYLAND

Art Things, Inc.
2 Annapolis Street
Annapolis, Maryland 21401

Nyborgs Inc.
517 North Charles Street
Baltimore, Maryland 21201

MASSACHUSETTS

Bromfield Pen
286 Summer Street
Boston, Massachusetts 02210

Hatfield's Color Shop, Inc.
859 Boylston Street
Boston, Massachusetts 02116

MICHIGAN

Art Alcove
33335 Grand River
Farmington, Michigan 48024

Favor Ruhl
4863 Woodward Avenue
Detroit, Michigan 48201

MINNESOTA

Art Sign Materials Company
2501 26th Avenue South
Minneapolis, Minnesota 55406

Van's Hobbies
2107 Ford Parkway
St. Paul, Minnesota 55116

MISSISSIPPI

The Artist's Shop
Edgewater Plaza Shopping Center
Gulfport, Mississippi 39501

MISSOURI

Art Mart
8112 Maryland Avenue
Clayton, Missouri 63105

Bader Artist Supply Company
1113 Locust Street
St. Louis, Missouri 63101

MONTANA

Art Market
501 Plaza
#3 5th Street North
Great Falls, Montana 59401

Rauthe Art & Frame
321 Avenue A
Callis Pell, Montana 59901

NEBRASKA

Standard Blue
10011 J Street
Omaha, Nebraska 68127

NEVADA

Daves Hallmark Cards & Books
2100 Idaho
Elko, Nevada 898

NEW HAMPSHIRE

The Artisans Workshop
Main Street
New London, New Hampshire 03257

The Out Back
44 Main Street
Durham, New Hampshire 03824

NEW JERSEY

Dupont Graphic Arts
745 Route 46
Parsippany, New Jersey 07054

Fair Lawn Stationery
12–17 River Road
Fair Lawn, New Jersey 07410

Pearl Paint
803 Route 17
Paramus, New Jersey 07652

NEW MEXICO

Artisan
717 Canyon Road
Santa Fe, New Mexico 87501

California Art Supply
2510 Central Avenue S.E.
Albuquerque, New Mexico 87106

NEW YORK

* Art Cove, Ltd.
60–09 Myrtle Avenue
Brooklyn, New York 11227
(*mail order*)

East Meadow Art Center
2344 Hempstead Turnpike
East Meadow, New York 11554

Sam Flax
25 East 28th Street
New York, New York 10011

NORTH CAROLINA

Fidler's Art Materials
The Cotton Exchange
312 Nut Street
Wilmington, North Carolina 28401

OHIO

Morse Graphic Art Supply
1938 Euclid
Cleveland, Ohio 44115

University of Ohio Bookstore
140 North Oval
Columbus, Ohio 43210

OREGON

Art Media
820 S.W. 10th Street
Portland, Oregon 97205

Great North West Art Supply Company
720 East 13th Street
Eugene, Oregon 97401

PENNSYLVANIA

Chestnut Hill Art Supply
8335 Germantown Avenue
Philadelphia, Pennsylvania 19118

Philadelphia Art Supply
25 South 8th Street
Philadelphia, Pennsylvania 19106

RHODE ISLAND

Block Artists Materials
129 Dyer Street
Providence, Rhode Island 02903

Rhode Island School of Design Bookstore
236 Benefit Street
Providence, Rhode Island 02903

SOUTH CAROLINA

Phoenix Artists Materials, Inc.
P.O. Box 1274
1025 Assembly Street
Columbia, South Carolina 29202

SOUTH DAKOTA

Index Stationers
310 Main Avenue
Brookings, South Dakota 57006

TENNESSEE

Doochin Enterprises
408 Gallatin Road South
Madison, Tennessee 37115

Griffin Supply Company
P.O. Box 23173–37202
633 Middleton Street
Nashville, Tennessee 37202

TEXAS

John Herweck, Inc.
310 Broadway
San Antonio, Texas 78205

Rush Company, Art & Drafting Supplies
5425 North Central Expressway
Dallas, Texas 75205

UTAH

Phillips Office Products
5115 Wintergreen
Murray, Utah 84107

Renel's Photo Blue Company
123 East 2nd Street
Salt Lake City, Utah 84110

VERMONT

H. G. Boutilier Company
112 Church Street
Burlington, Vermont 05401

North East Crafts Center
Brattleboro North Plaza
Brattleboro, Vermont 05301

VIRGINIA

Calligraphic Ink, Inc.
1675 Jeff Davis Highway
Arlington, Virginia 22205

J. F. Thomas Company, Inc.
5825 Leesburg Pike
Bailey's Cross Roads, Virginia 22041

WASHINGTON

Seattle Art, Inc.
1816 8th Avenue
Seattle, Washington 98101

WEST VIRGINIA

Barry's Office Service, Inc.
P.O. Box 1030
Morgantown, West Virginia 26505

WISCONSIN

Madison Art Supply Company, Inc.
921 University Avenue
Madison, Wisconsin 53715

Palette Shop
409 East Michigan Street
Milwaukee, Wisconsin 53202

DISTRICT OF COLUMBIA

Fahrney's
1418 New York Avenue, N.W.
Washington, D.C. 20005

Ginns-Muth
919 E Street, N.W.
Washington, D.C. 20004